Remembering
Chicago

Russell Lewis

TURNER
PUBLISHING COMPANY

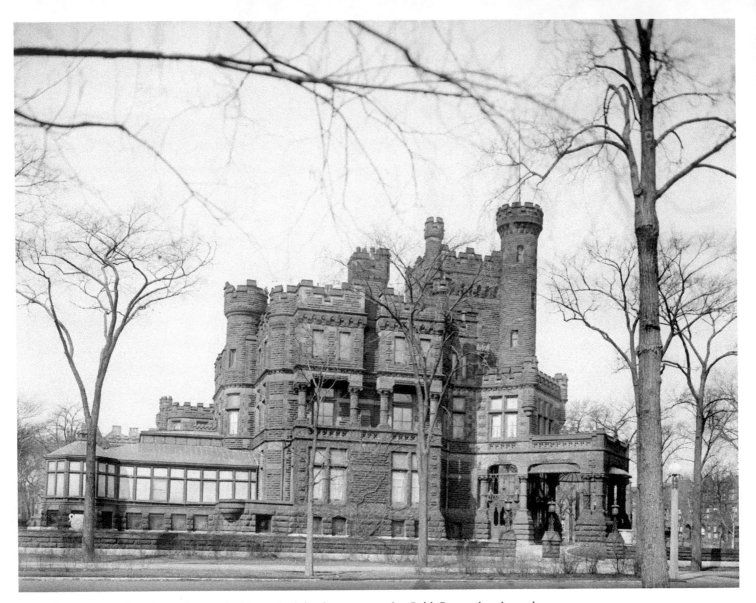

Potter Palmer's mansion, shown here in 1914, sparked development on the Gold Coast when he and his family moved here in 1885. Before that, Prairie Avenue, south of the business district, was the most desirable address in Chicago. The Palmer mansion was demolished in 1950.

Remembering
Chicago

Turner Publishing Company
www.turnerpublishing.com

Remembering Chicago

Library of Congress Control Number: 2010902280

ISBN: 978-1-59652-607-5

Printed in the United States of America

ISBN: 978-1-68336-815-1 (pbk.)

CONTENTS

The Post Office and Custom
House complex was located at
the northwest corner of Dearborn
and Monroe.

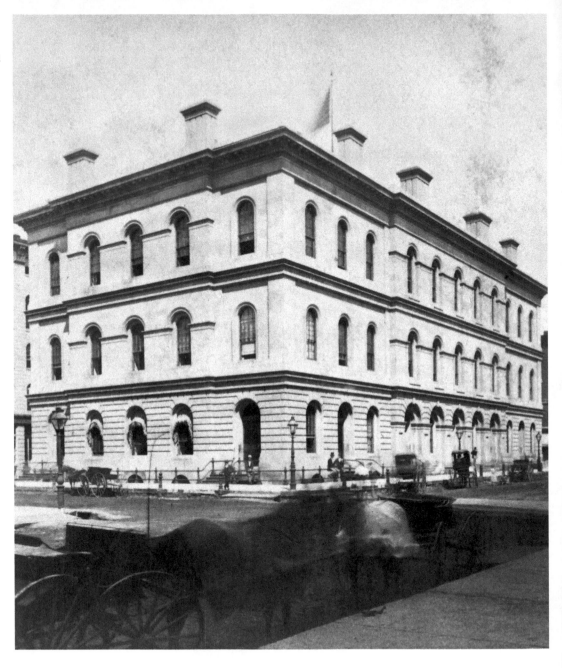

Acknowledgments

This book and the partnership between Turner Publishing Company (TPC) and the Chicago History Museum (CHM) were conceived by Todd Bottorff, president of TPC, and Gary Johnson, president of the CHM. Their enthusiasm for this book project was an ongoing source of support, and I am grateful for all of their encouragement.

Lesley Martin of CHM brought both research and editing skills to the book. She did a remarkable job of fact checking and editing the captions, and she conducted crucial research of the Museum's collection for additional images. I am grateful for her professionalism and high standards.

Rob Medina, also of CHM, facilitated making digital files of these images for production in record time, and I appreciate all of his hard work to meet a challenging schedule. CHM photographers Jay Crawford and John Alderson performed their magic on these vintage images, ensuring they are presented in their best light while retaining their historic integrity as visual artifacts.

We would also like to thank the organizations and corporations that provided support for this work. They include Chicago Architecture Foundation, Turtle Wax, and others. Their interest in Chicago history has helped preserve a vital part of the city's past.

Through the efforts of all of these people and institutions, we are pleased to present *Remembering Chicago*.

PREFACE

Chicago has many thousands of historic photographs that reside in archives, both locally and nationally. The collections of the Chicago History Museum represent a most extraordinary resource for those who seek to understand Chicago's history and culture. This book began with the observation that, while those photographs are of great interest to many, they are not widely accessible. During a time when Chicago is looking ahead and evaluating its future course, many people are asking, How do we treat the past? These decisions affect every aspect of the city—architecture, public spaces, commerce, and infrastructure—and these, in turn, affect the way that people live their lives. This book seeks to provide easy access to a valuable, objective look into the history of Chicago.

The power of photographs is that they are less subjective than words in their treatment of history. Although the photographer can make subjective decisions regarding subject matter and how to capture and present it, photographs seldom interpret the past to the extent textual histories can. For this reason, photography is uniquely positioned to offer an original, untainted look at the past, allowing the viewer to learn for himself what the world was like a century or more ago.

This project represents countless hours of review and research. The researchers and writer have reviewed thousands of photographs in numerous archives. We greatly appreciate the generous assistance of the archivists listed in the acknowledgments of this work, without whom this project could not have been completed.

The goal in publishing this work is to provide broader access to this set of extraordinary photographs that seek to inspire, provide perspective, and evoke insight that might assist people who are responsible for determining Chicago's future. In addition, the book seeks to preserve the past with adequate respect and reverence.

With the exception of touching up imperfections that have accrued with the passage of time and cropping where necessary, no changes have been made. The focus and clarity of many images are limited to the technology and the ability of the photographer at the time they were recorded.

The work is divided into eras. Beginning with some of the earliest known photographs of Chicago, the first section records photographs from the eve of the Civil War to around 1870. The second section covers the devastation of the Great Fire and the reconstruction that culminated in the Columbian Exposition. Section Three spans the beginning of the twentieth century to World War I, and section Four moves from World War I to the years between the world wars. The last section looks briefly at the postwar era ushered in by World War II.

In each of these sections we have made an effort to capture various aspects of life through our selection of photographs. People, commerce, transportation, infrastructure, religious institutions, and educational institutions have been included to provide a broad perspective.

We encourage readers to reflect as they go walking in Chicago, stroll along the lakefront, or explore one of the city's neighborhoods. It is the publisher's hope that in utilizing this work, longtime residents will learn something new and that new residents will gain a perspective on where Chicago has been, so that each can contribute to its future.

—*Todd Bottorff, Publisher*

The original Palmer House was erected in 1851 at the corner of State and Quincy streets.

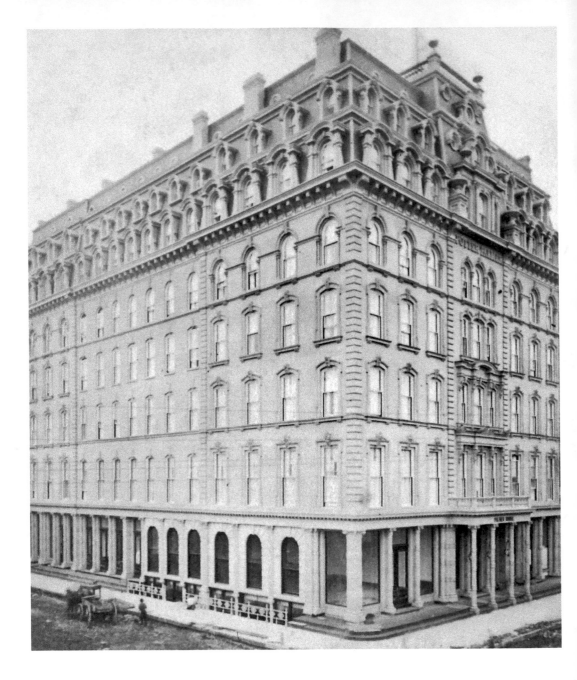

Before the Fire

(1850s–1870)

St. James was the first Episcopal church in Chicago. It was originally at Cass (now Wabash) and Illinois streets. In 1857, the congregation moved to its new (and current) location at the southeast corner of Cass and Huron streets.

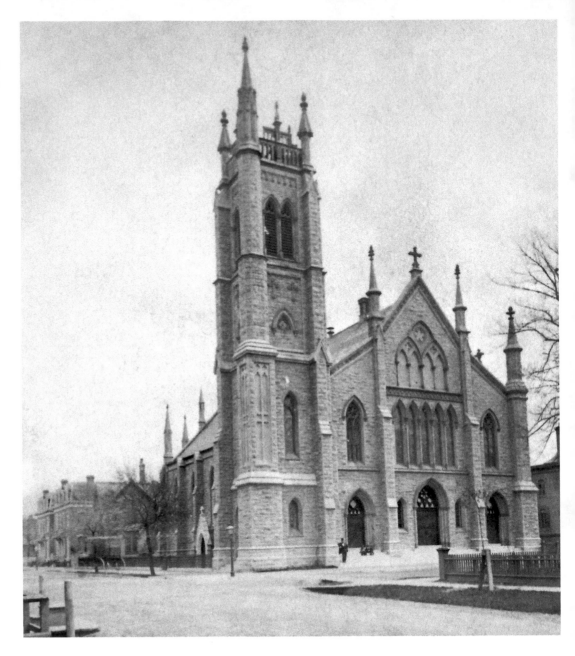

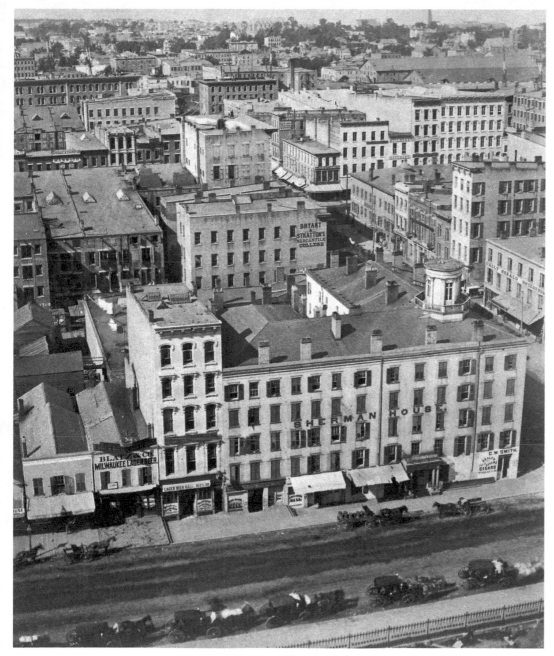

A view of Randolph Street from atop the Courthouse in 1858. The Sherman House was one of the most impressive buildings built in the city during its early years.

The intersection of Clark and Randolph was busy even in 1858. Lake Michigan is visible in the background.

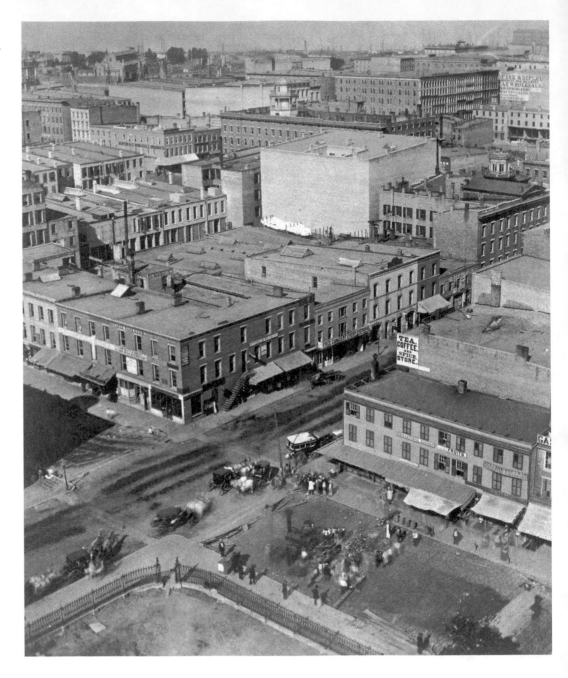

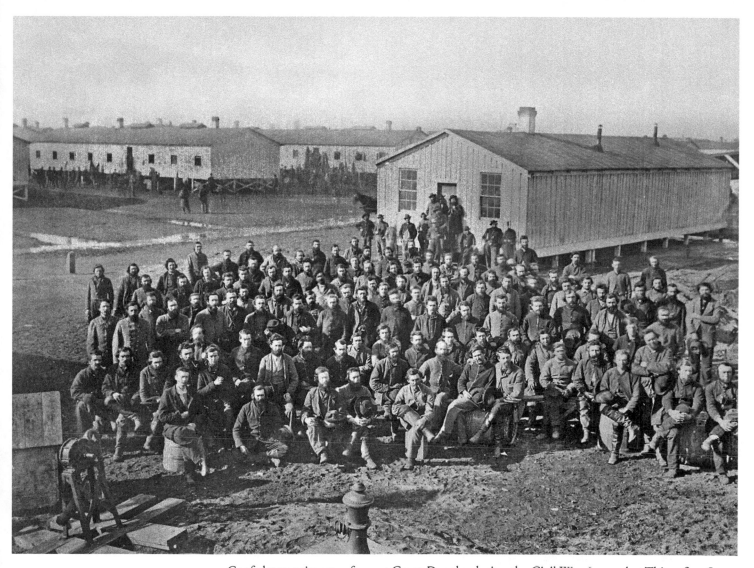

Confederate prisoners of war at Camp Douglas during the Civil War. Located at Thirty-first Street and Cottage Grove Avenue, Camp Douglas housed as many as 26,000 prisoners over the course of the war. Harsh conditions led to the deaths of some 4,000 men, who were buried in unmarked graves in Chicago's City Cemetery. When it closed in 1867, their remains were moved to a mass grave at Oak Woods Cemetery. A monument was erected at the "Confederate Mound" in 1893.

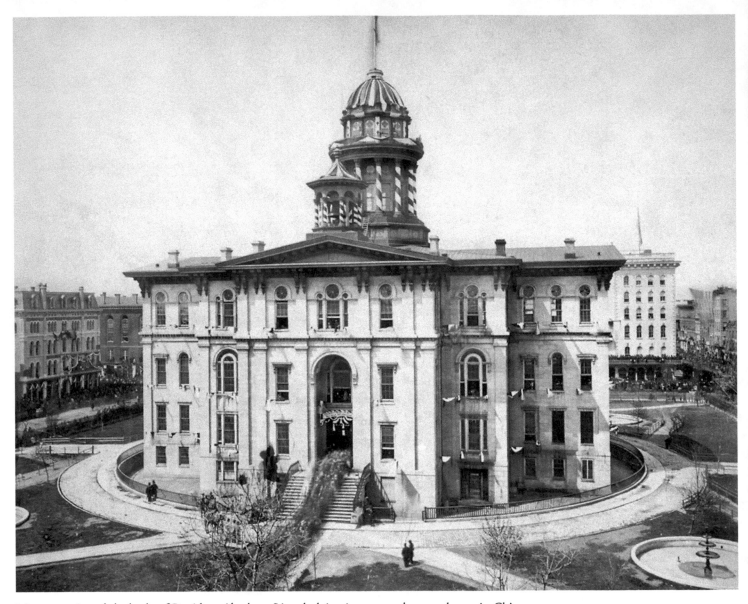

Mourners viewed the body of President Abraham Lincoln lying in state at the courthouse in Chicago, one of the stops on the journey from Washington, D.C., to Springfield, Illinois. In Chicago, Lincoln's remains were transferred to a special train equipped with George Pullman's first "Pioneer" palace car.

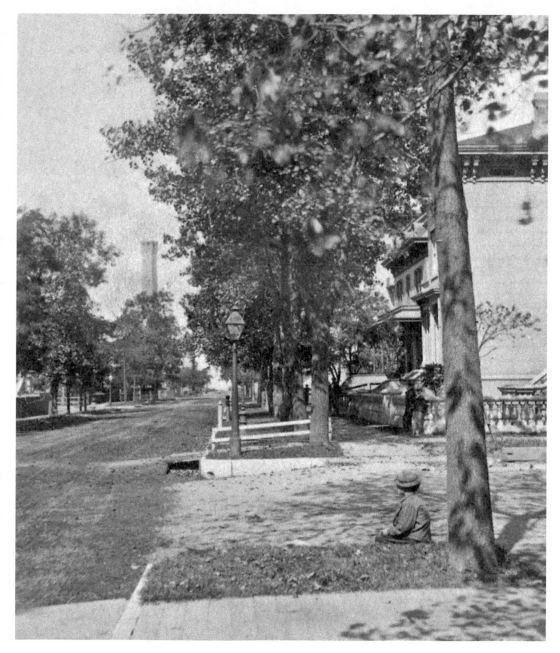

Pine Street was the name given to the continuation of Michigan Avenue north of the river, today known as the "Magnificent Mile."

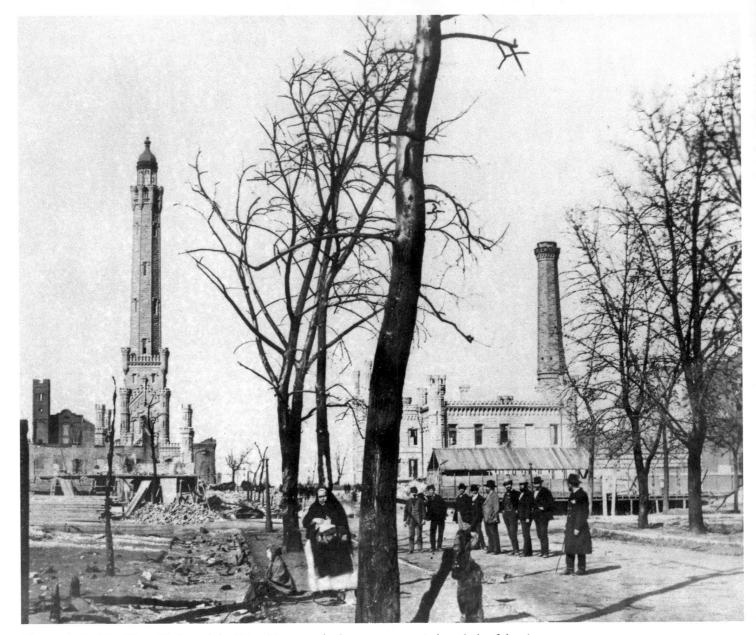

The survival of the Water Works and the Water Tower made these structures vital symbols of the city.

THE GREAT FIRE AND RECONSTRUCTION

(1871–1899)

The Great Chicago Fire of 1871 devastated the city. The ruins of the Van Buren Street Bridge are shown here.

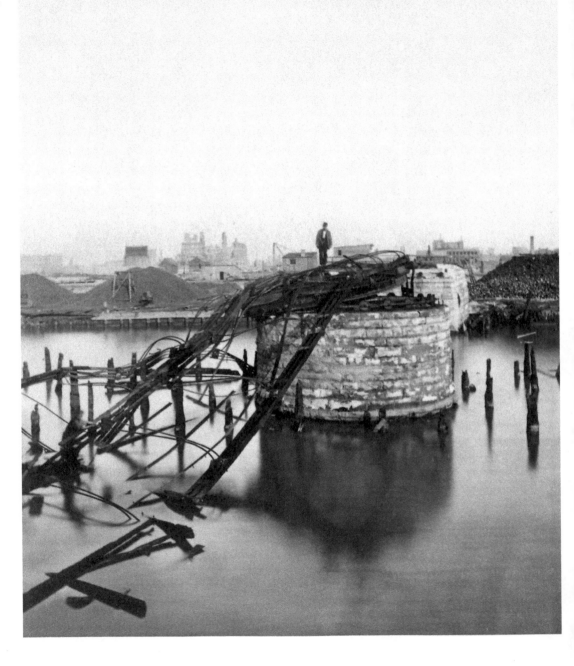

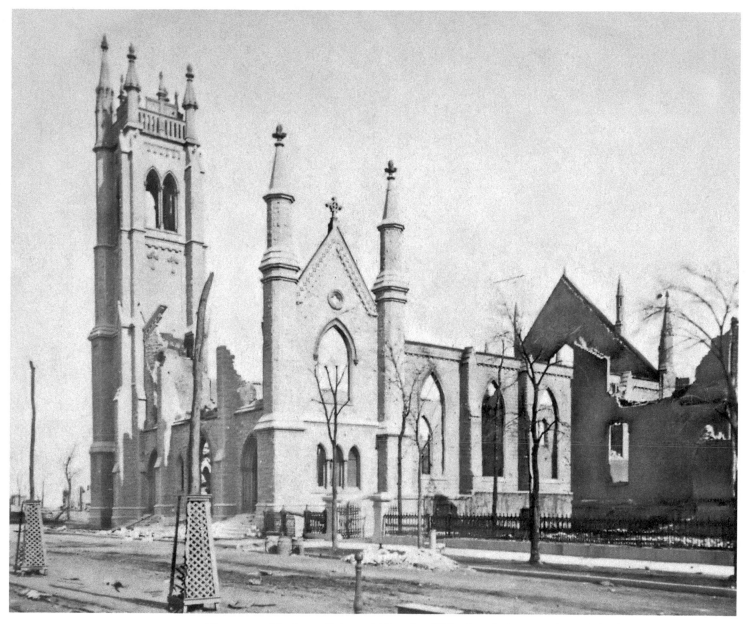

The tower of St. James Episcopal Church at Wabash and Huron withstood the fire, although the main building was destroyed.

The Ogden mansion, on the site now occupied by the Newberry Library (Walton Street, between Dearborn and Clark streets), was saved partly by a shift in the wind and partly by covering portions of the building with soaked carpets.

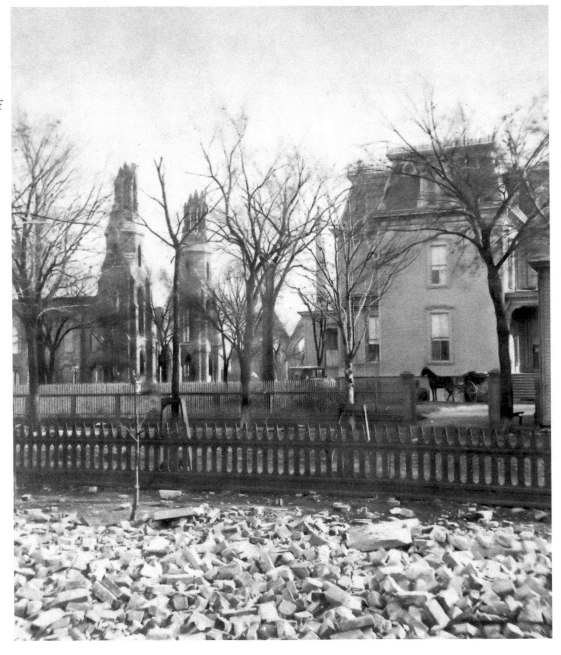

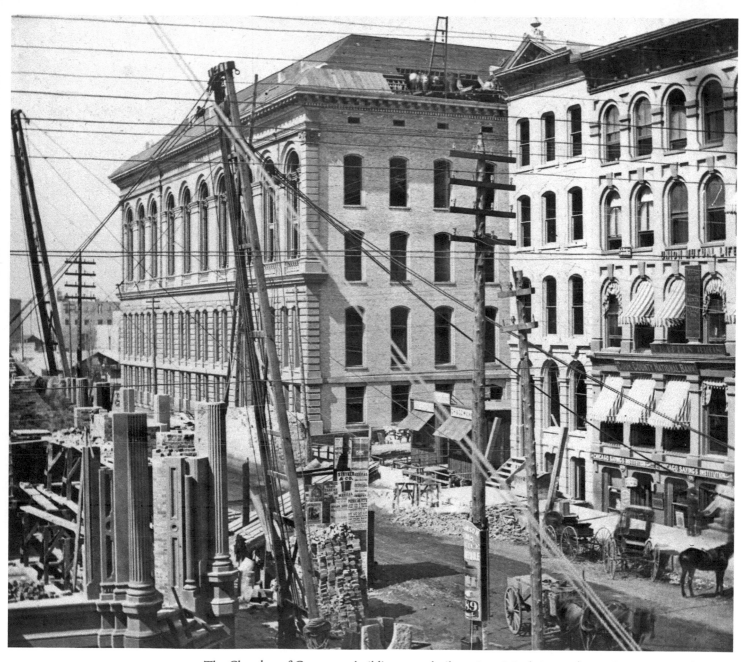

The Chamber of Commerce building was rebuilt on its original site on the southeast corner of LaSalle and Washington.

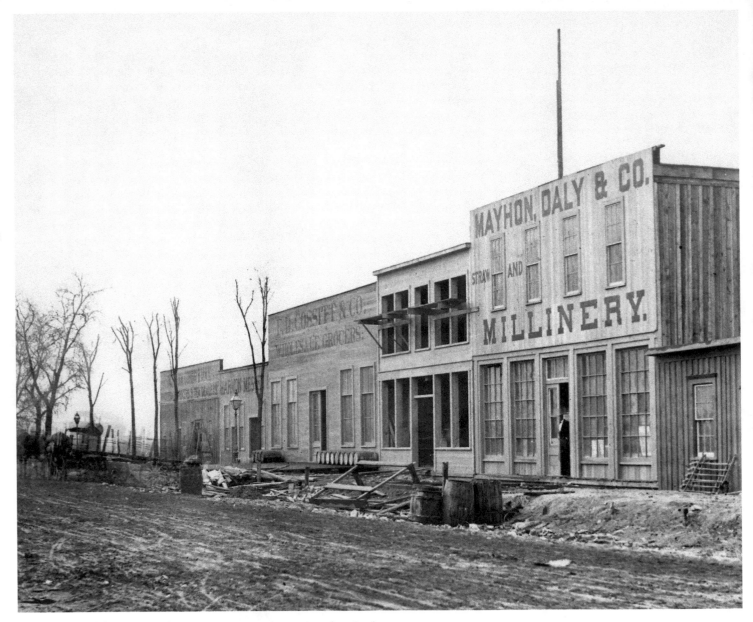

Temporary buildings on Michigan Avenue sprang up soon after the fire.

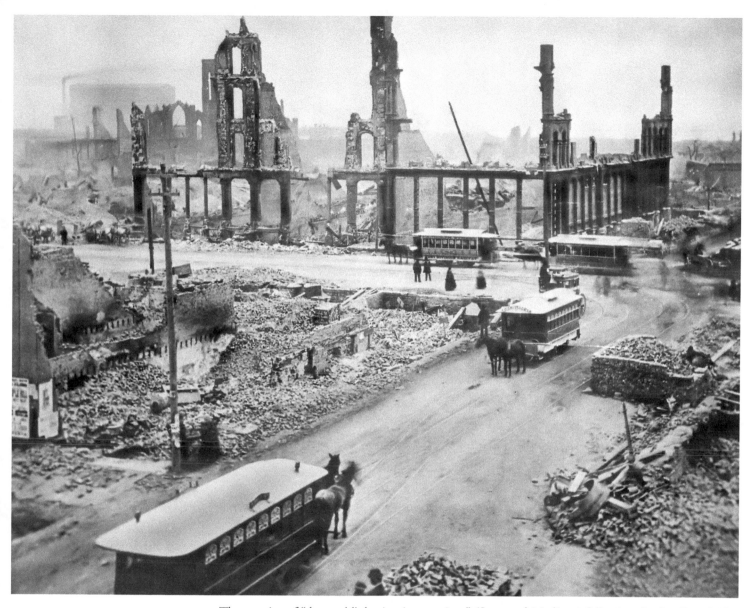

The remains of "the world's busiest intersection," (State and Madison) following the fire. Broadsides can be seen posted on some of the ruins.

Michigan Avenue north of the Chicago River (then known as Pine Street) as it appeared after the fire.

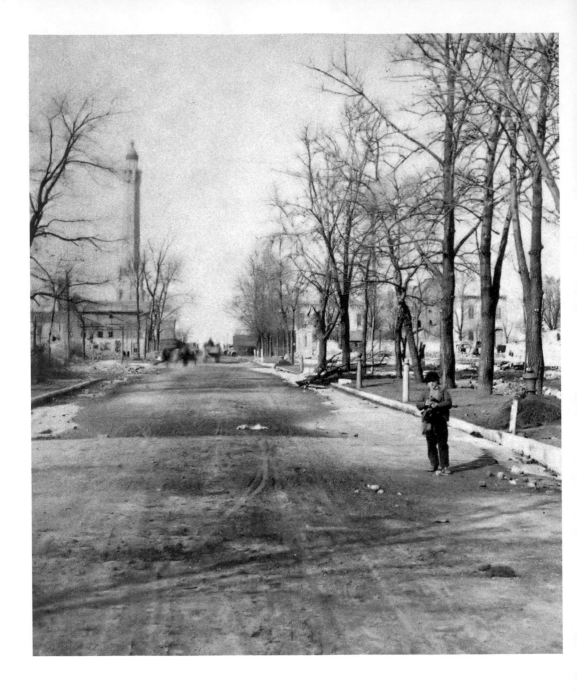

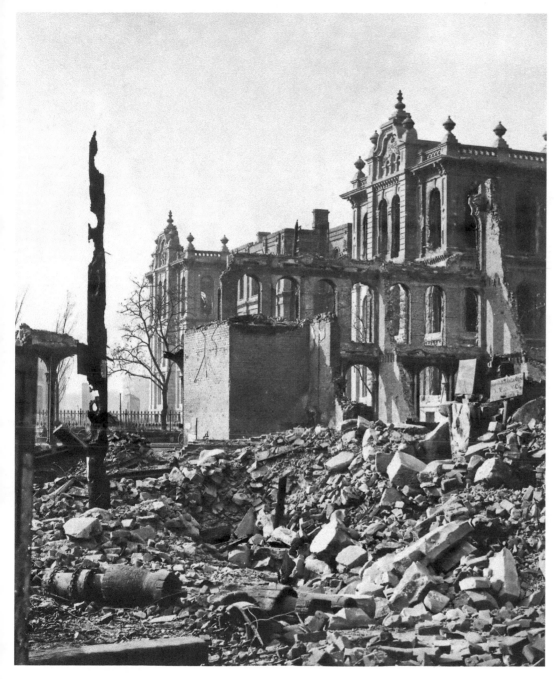

Post Office and Custom House, 1871. Haverley's Theater benefited from the destruction of this building—parts of its ruins were re-used in construction of the theater.

Piles of rubble and shells of buildings awaiting demolition lined Chicago's streets in the aftermath of the fire.

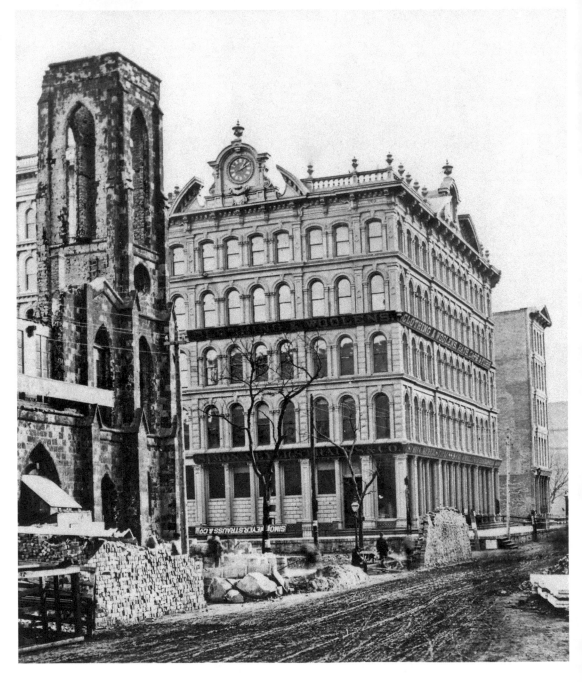

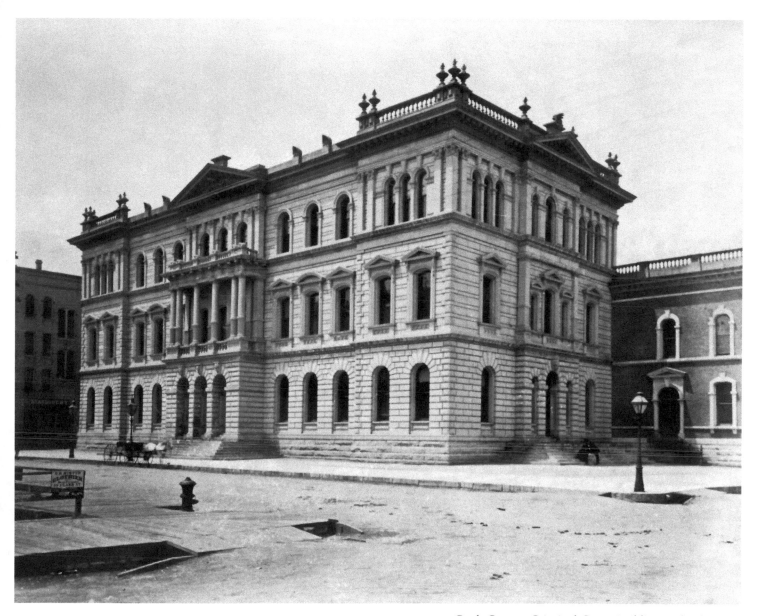

Cook County Criminal Court Building and jail, 1879.

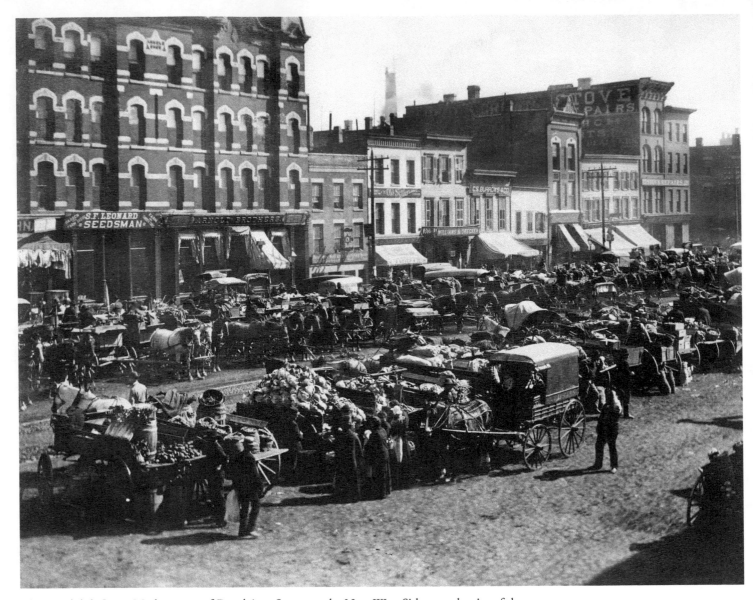

The Randolph Street Market, west of Desplaines Street on the Near West Side, was the site of the Haymarket Riot in 1886. The May 4th rally started so peacefully that Mayor Carter Harrison left early. But when an unknown person threw a bomb into the police line that had formed to disperse the crowd, one officer was killed immediately. Police opened fire on the crowd, injuring and killing both protestors and police.

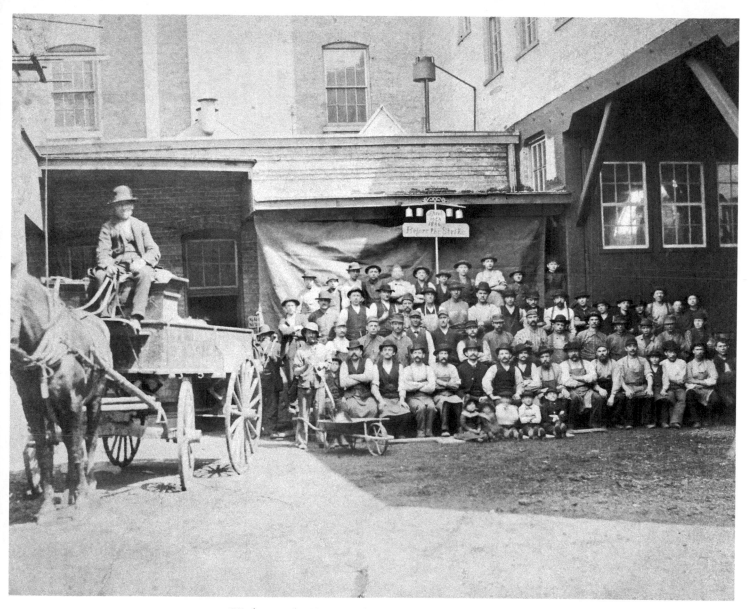

Workers at the Horn Brothers Furniture Company gather for a group portrait on April 30, 1886. The banner in the midst of the workers had the date with the notation "Before the strike." This was a reference to the nationwide one-day labor walkout scheduled on May 1, 1886, in support of an eight-hour work day.

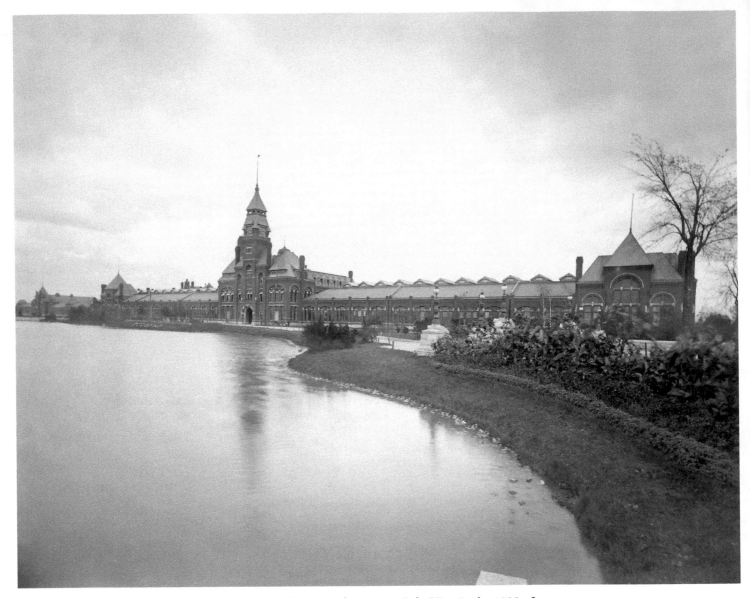

The South Factory wing of the Pullman railroad works is seen from across Lake Vista in the 1880s. In keeping with George Pullman's demand for efficiency and self-sufficiency, the manmade Lake Vista served a dual purpose. The exhaust from the giant Corliss engine, which powered the factory, filled Lake Vista. Then workers used the ice from the lake on Pullman cars.

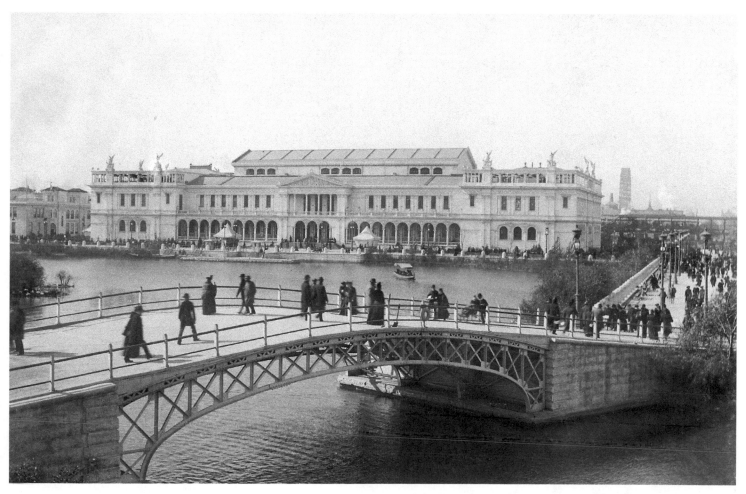

The Woman's Building at the World's Columbian Exposition.

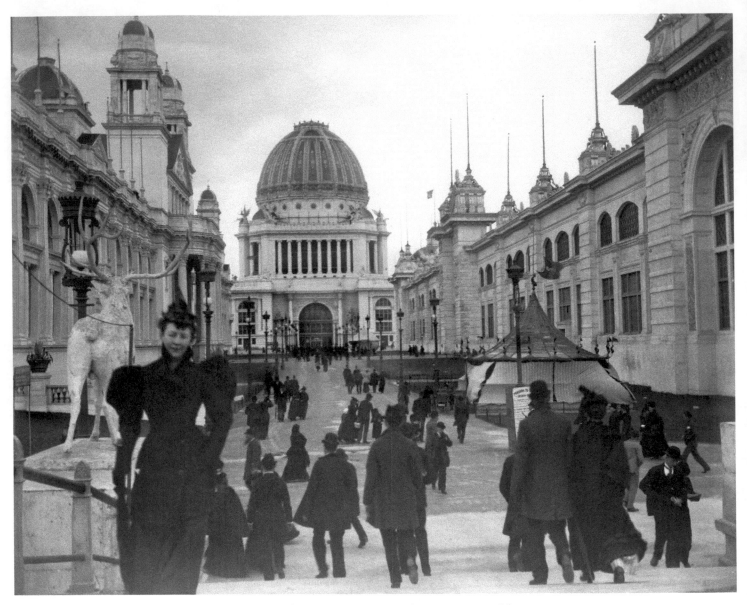

"Chicago Day" at the Columbian Exposition was held October 9, 1893, on the anniversary of the Great Fire.

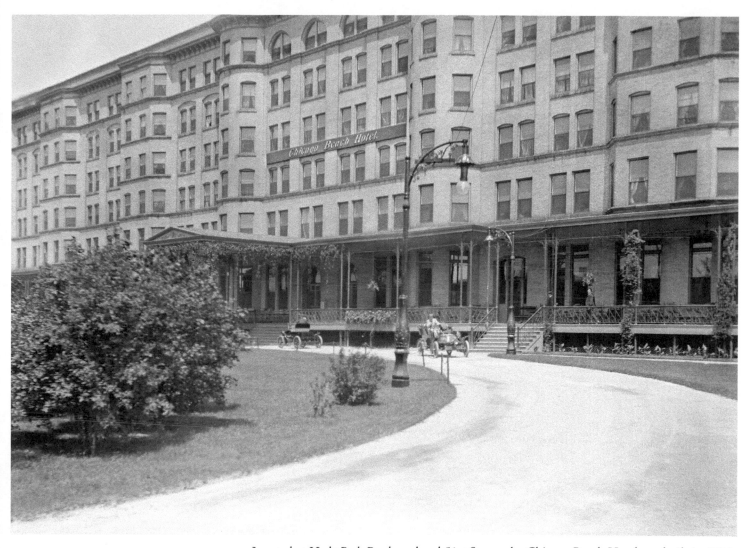

Located at Hyde Park Boulevard and 51st Street, the Chicago Beach Hotel was built in 1892. Many hotels were built in the Hyde Park area in anticipation of crowds for the World's Columbian Exposition of 1893 and were later converted to luxury hotels or apartments.

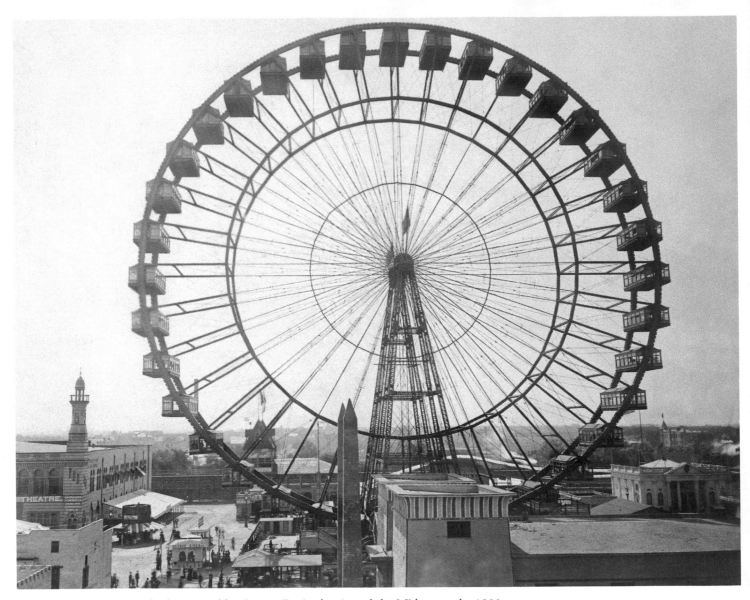

The world's first Ferris Wheel, invented by George Ferris, dominated the Midway at the 1893 World's Columbian Exposition. The 264-foot-tall structure had 36 cars, each carrying as many as 60 passengers. In 1894, it was dismantled and later rebuilt at North Clark Street and Wrightwood Avenue. It remained there until 1903 when it was again dismantled, to be moved to St. Louis for the Louisiana Purchase Exposition.

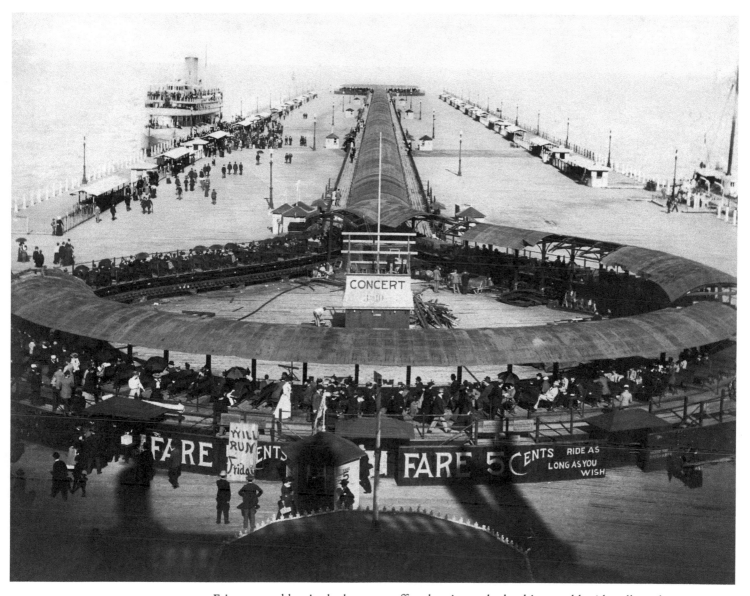

Fairgoers could arrive by boat, get off at the pier, and take this movable sidewalk to the entrance to the Court of Honor. The Columbia Exposition occupied 630 acres in Jackson Park and the Midway Plaisance. The main exposition site was bounded by Stony Island Avenue on the west, 67th Street on the south, Lake Michigan on the east, and 56th Street on the north, with the Midway Plaisance extending west between 59th and 60th streets to Cottage Grove.

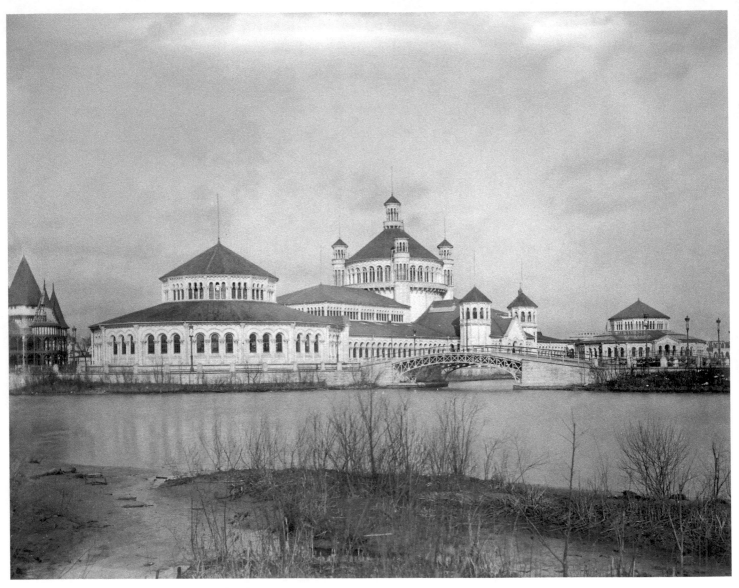

The Fish and Fisheries Building at the Columbian Exposition.

PLANS FOR A GREAT CITY

(1900–1917)

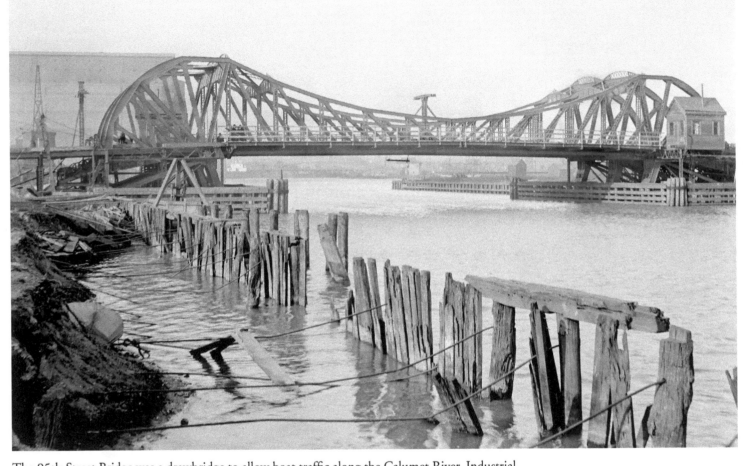

The 95th Street Bridge was a drawbridge to allow boat traffic along the Calumet River. Industrial development in this area started in 1869 when Congress appropriated money for a harbor in South Chicago. In 1903, when this photograph was taken, the Calumet area was home to industry giants such as U.S. Steel South Works and the Pullman Works.

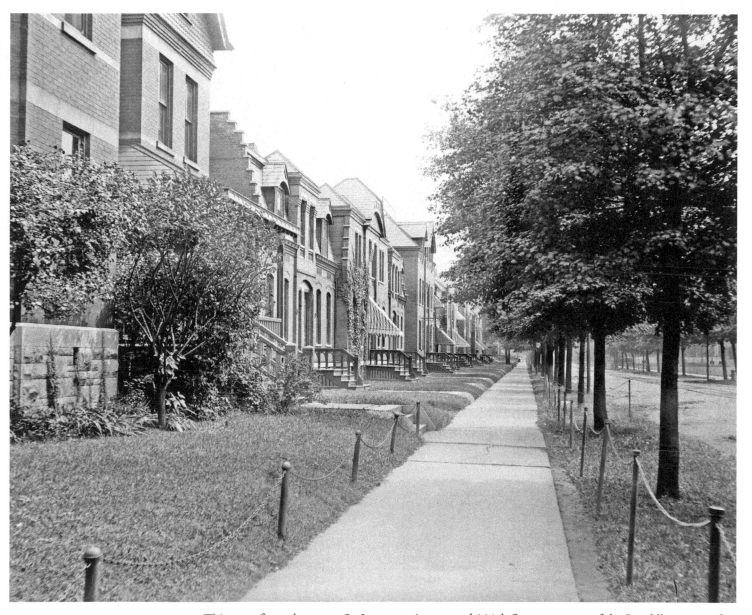

This row of townhouses at St. Lawrence Avenue and 111th Street was part of the "world's most perfect town" created by George Pullman in an attempt to both house workers in his Pullman Palace Car Company and bring in a 6 percent profit for the company. In addition to homes, Pullman built shops, a church, schools, and a library in the neighborhood surrounding the factory.

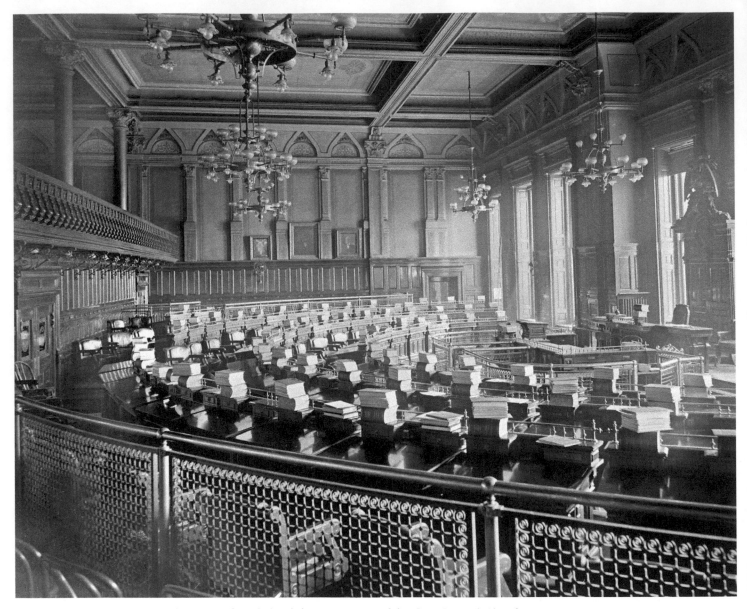

The speaker's rostrum, pictured in 1903, from behind the seating area of the City Council Chamber. This combined City Hall and County Building was completed in 1885, but did not survive long. Demolition to make way for the current city-county building began in 1906.

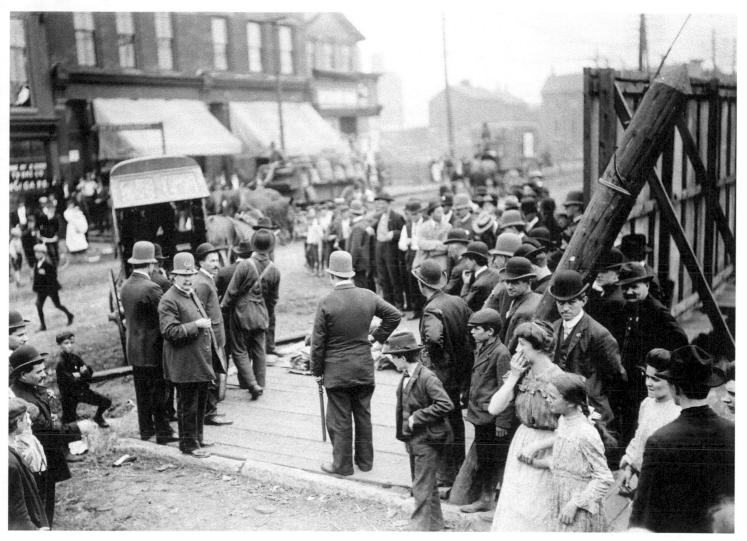

Workers struck the Union Stock Yard for the second time in 1904. Working conditions at the stockyards were very challenging. However, an attempt by the Amalgamated Meat Cutters and Butcher Workmen to unionize failed, partially because of an inability to join people of various ethnic groups into a unified group.

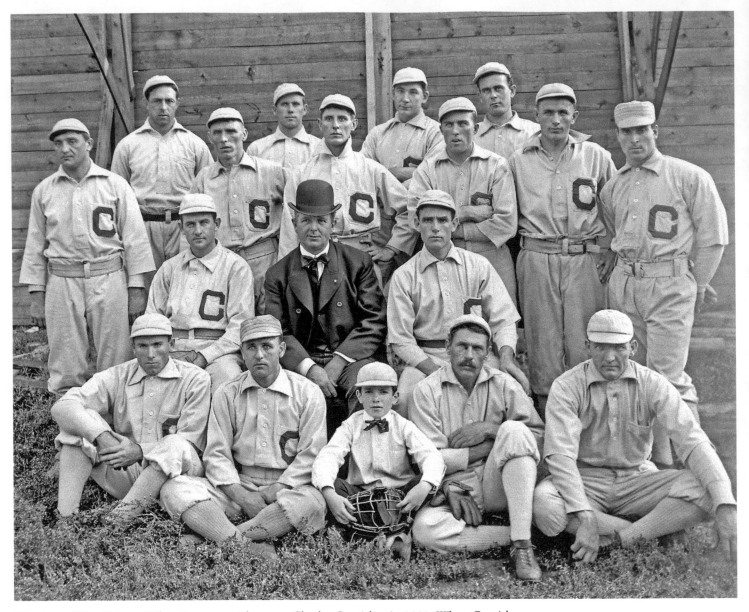

Members of the Chicago White Sox pose with owner Charles Comiskey in 1903. When Comiskey moved his White Stockings from St. Paul in 1900, headline editors began to shorten the team's name, and the team soon officially changed its name.

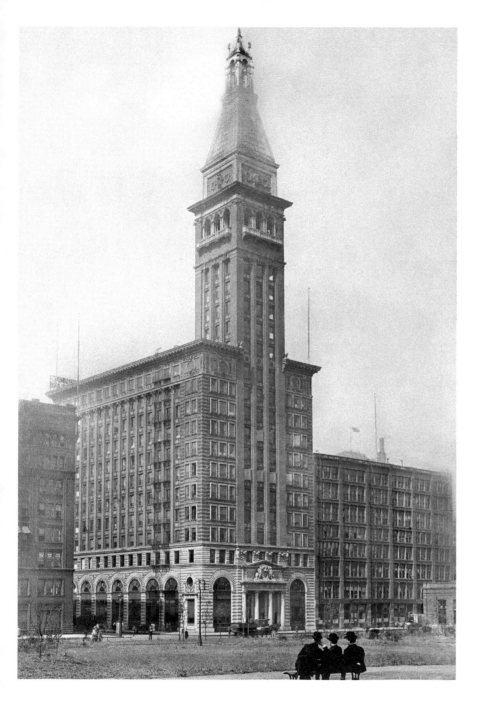

The Montgomery Ward and Company Administration building was erected at 6 North Michigan Avenue in 1899. Pictured here in 1903, the elaborate building was designed to evoke trust in the mail order business begun in 1872 by Aaron Montgomery Ward. At 394 feet, it was among the tallest buildings in the city when completed.

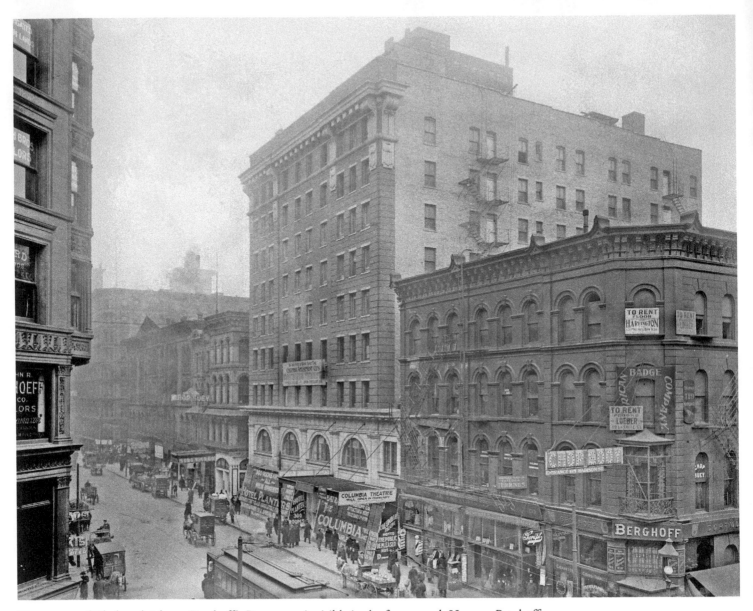

The corner of Clark and Adams. Berghoff's Restaurant is visible in the foreground. Herman Berghoff began selling his Dortmunder beer at this location in the 1890s. A Chicago institution, the restaurant did not close until 2006. Carlyn Berghoff, daughter of the last owner, re-opened in the same space with a cafe and catering business.

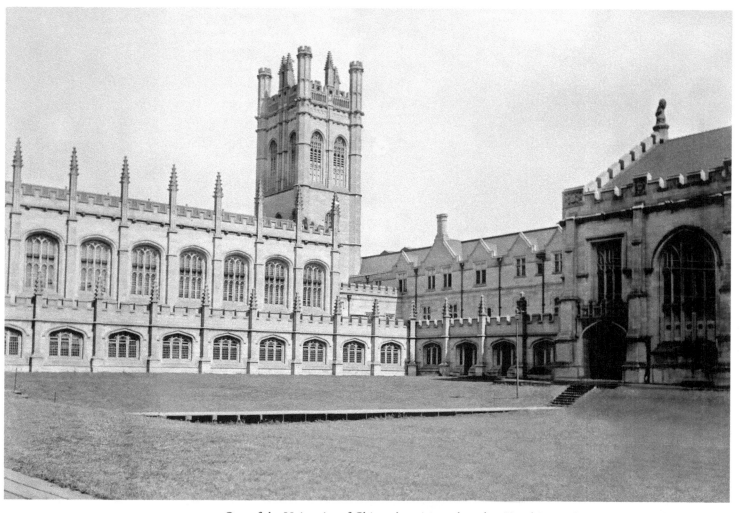

One of the University of Chicago's main quadrangles, Hutchinson Court, was named in honor of Charles L. Hutchinson, one of the university's original benefactors. Buildings along the court were (from left to right): Hutchinson Hall, John J. Mitchell Tower, the Reynolds Club, and Mandel Hall. The quadrangle is pictured shortly after it was built in 1903.

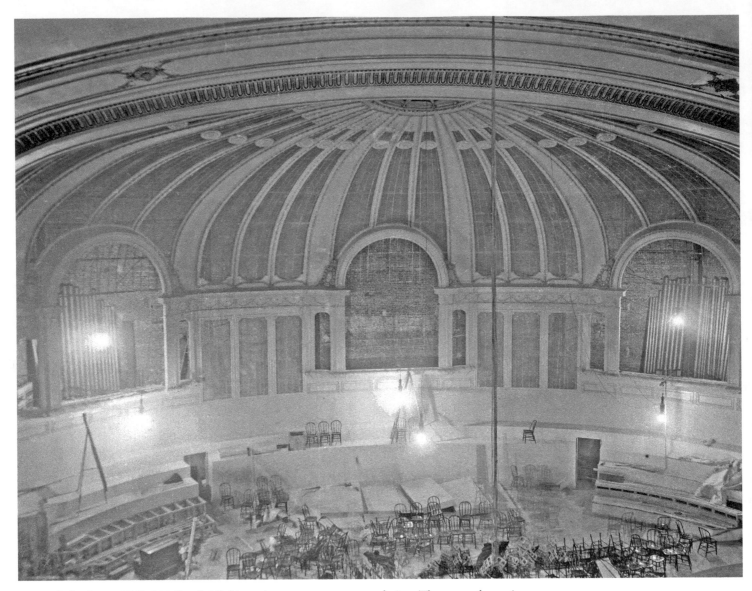

In 1904, Orchestra Hall, 220 South Michigan Avenue, was near completion. The stage, shown in this view, was still piled with chairs and building materials. The hall, designed by architect Daniel Burnham, was built to house the Chicago Orchestra. The Chicago Symphony Orchestra, as it would later be known, is one of the oldest symphonies in the United States.

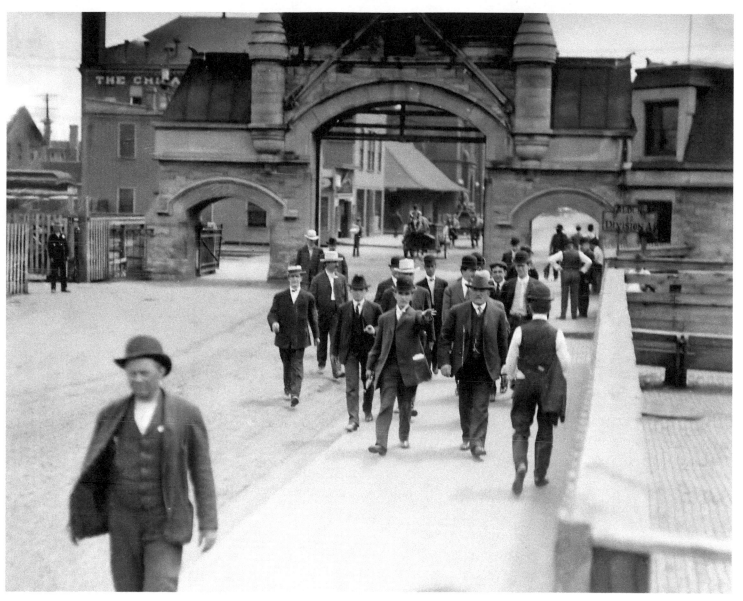

The arched gate, pictured here in 1906, was the entrance to Union Stock Yards. Built in 1879 and designed by architects Daniel Burnham and John Root, it still stands at Exchange Avenue and Peoria Street. A limestone steer head over the central arch (facing opposite entrance) is traditionally thought to represent "Sherman," a prize-winning bull named after John B. Sherman, one of the founders of the Union Stock Yard and Transit Company.

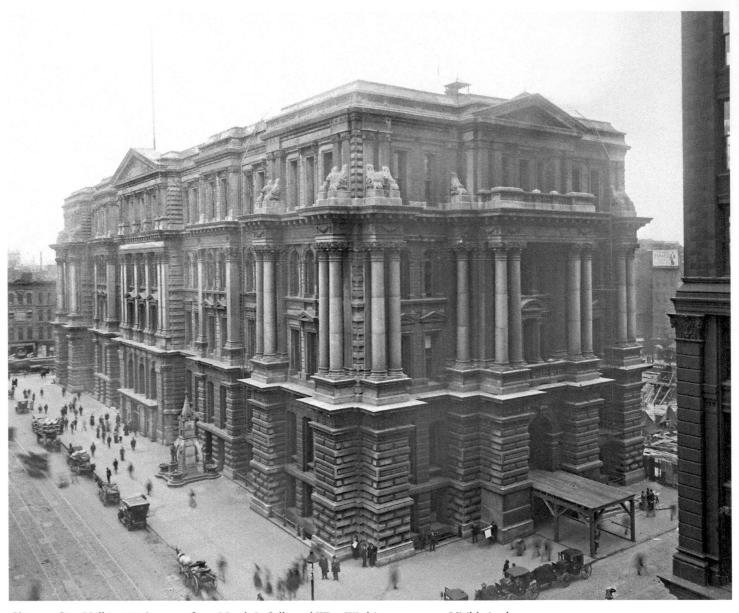

Chicago City Hall in 1906 as seen from North LaSalle and West Washington streets. Visible in the background is the rubble left after the demolition of the formerly adjacent County Building.

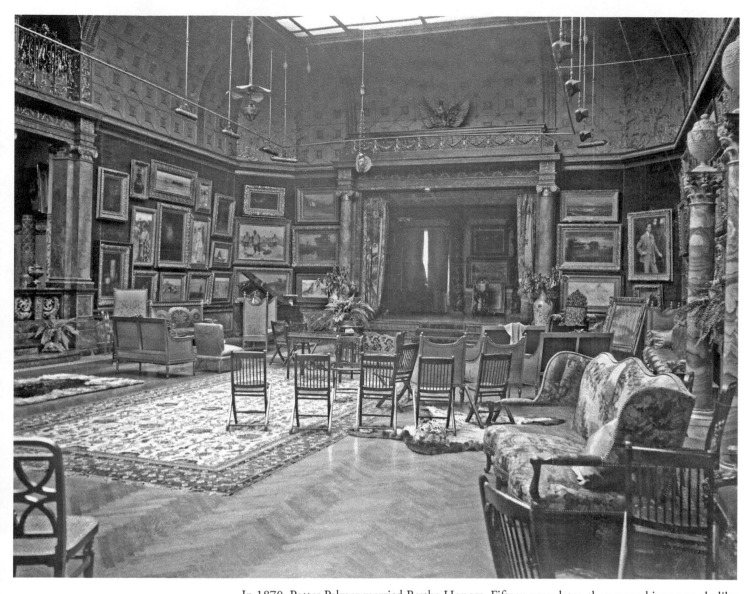

In 1870, Potter Palmer married Bertha Honore. Fifteen years later, they moved into a castle-like residence at 1350 North Lake Shore Drive. A portion of the Palmers' extensive art collection can be seen hung gallery-style on the walls in this image, recorded in 1907. In the 1860s, Potter Palmer started a dry goods business with Marshall Field and Levi Leiter, but soon left that business, going on to develop real estate on State Street.

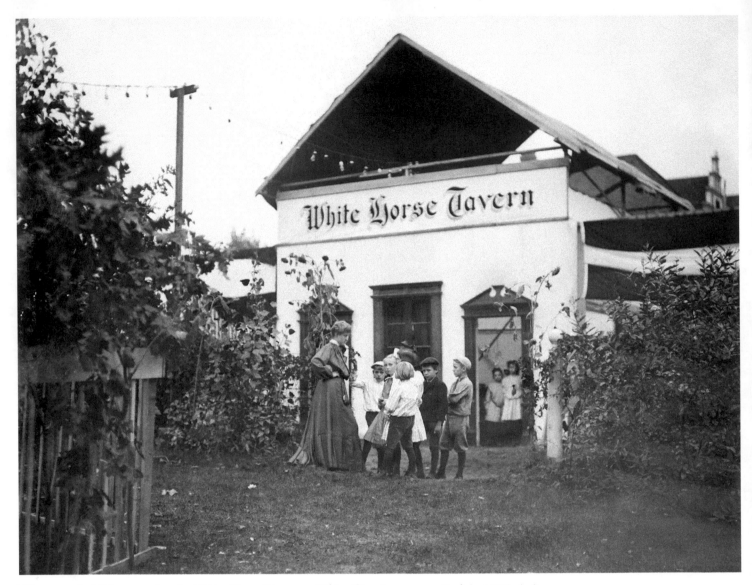

Women and children stand at the White Horse Tavern at White City Amusement Park in 1905. At its heyday, White City, located between 63rd Street and South Park Avenue, advertised itself as the largest of its kind in the nation. It closed in 1933.

Hull House, 800 South Halsted Avenue, the settlement house established in 1889 by Jane Addams and Ellen Gates Starr. The settlement house began in a dilapidated mansion built by real-estate developer Charles J. Hull in 1856. When the neighborhood began to decline, then-owner Miss Helen Culver rented the Hull Mansion to Addams and Starr. By 1907, the settlement had grown into the 13-building complex seen here.

Wendell Phillips High School, 244 East Pershing Road, is the namesake of the nineteenth-century abolitionist. Built in 1904, it had a racially mixed student body during its early history, becoming predominantly African-American by 1920. The school has many notable graduates including the nucleus of the Harlem Globetrotters basketball team, entertainers Nat "King" Cole and Dinah Washington, businessmen John H. Johnson and George E. Johnson, and Alonzo S. Parham, the first African-American to attend West Point.

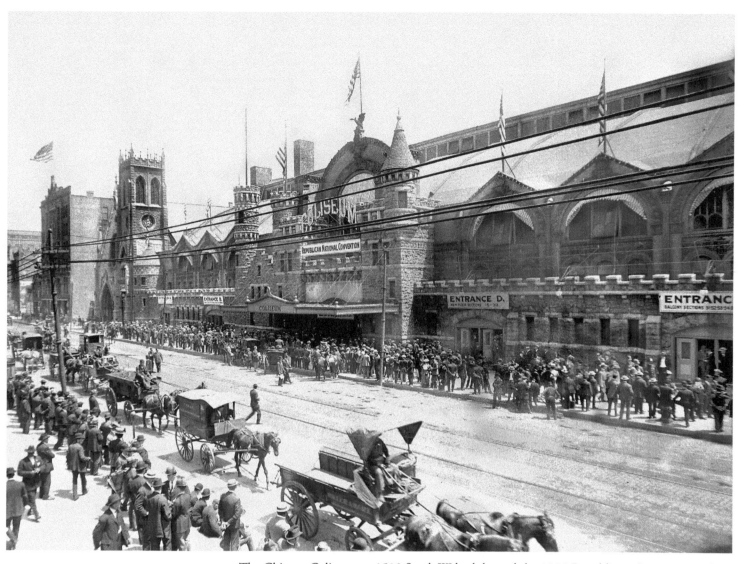

The Chicago Coliseum at 1513 South Wabash hosted the 1908 Republican Convention where President Theodore Roosevelt nominated his successor, William Howard Taft of Ohio. Altogether, the Democratic and Republican parties picked Chicago as the site for a total of 25 political conventions between 1860 and 1996.

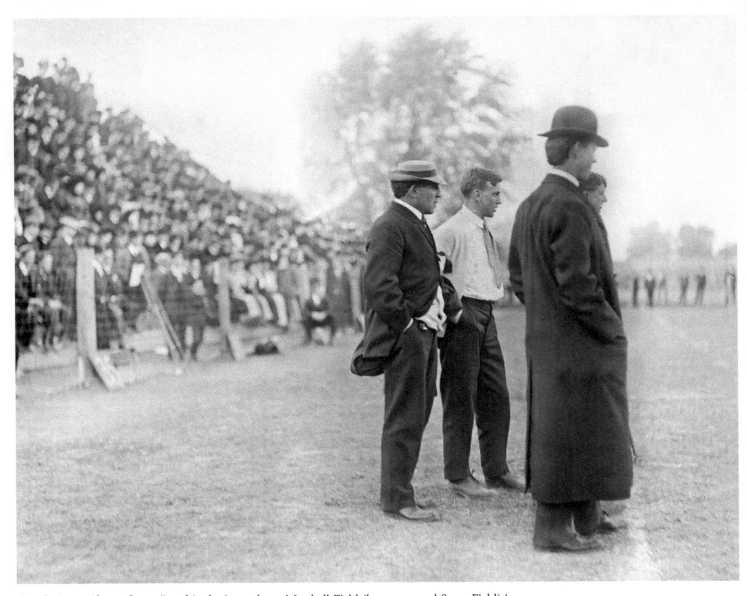

Coach Amos Alonzo Stagg (in white hat) stands on Marshall Field (later renamed Stagg Field) in 1905. Stagg was coach at University of Chicago for 40 years, coaching basketball and football. Stagg gained national recognition for his accomplishments as a player and coach: he was a member of the 1951 charter class of the College Football Hall of fame and one of the first groups of inductees into the Basketball Hall of Fame in 1959.

Palmer Park was part of a ten-park system that opened in 1905 to provide breathing space to residents in Chicago's crowded tenement district. The park was named in recognition of Potter Palmer, who served on the South Park Commission. Located at 111th Street and South King Drive, Palmer Park is in the Roseland community.

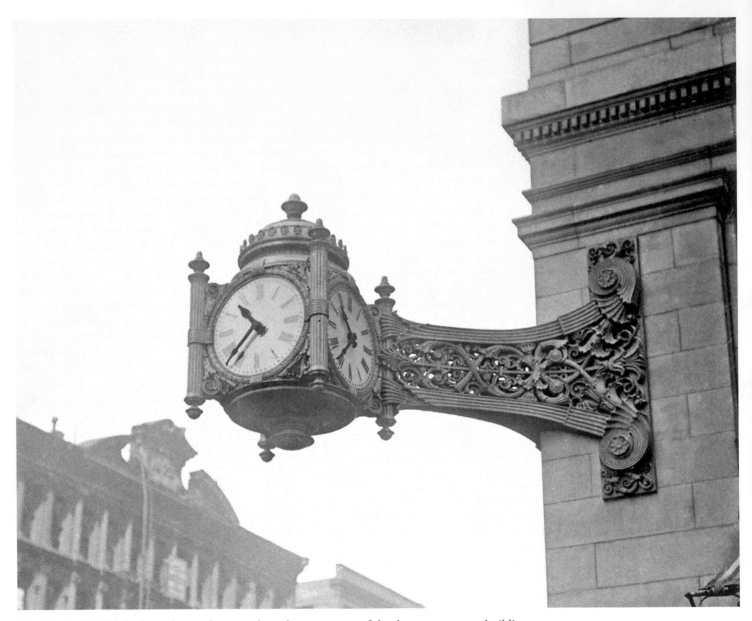

The Marshall Field clocks at the northwest and southwest corners of the department store building are well-known landmarks in downtown Chicago. By the time this picture was taken in 1907, the 12-story granite building, designed primarily by Daniel Burnham and Co., occupied the entire block bordered by State, Washington, and Randolph streets and Wabash Avenue in Chicago's Loop.

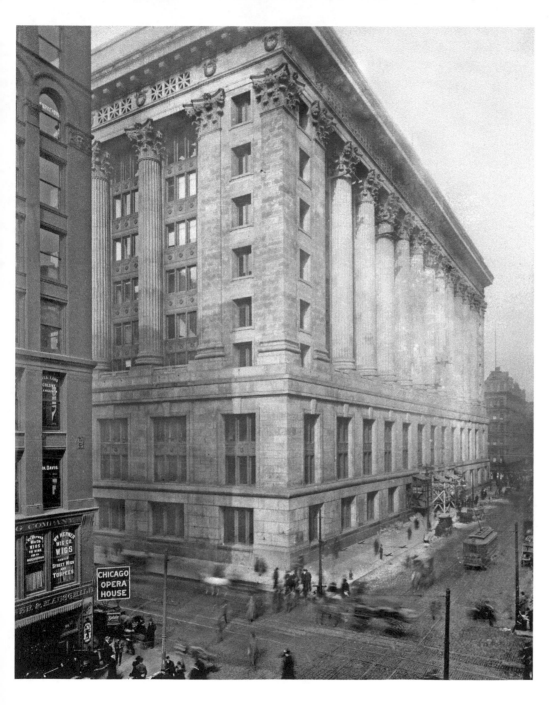

The county portion of the City Hall and County Building was completed first. The southeast corner, at North Clark and West Washington streets, was photographed here in 1907. Construction on the city half of the complex began in 1909.

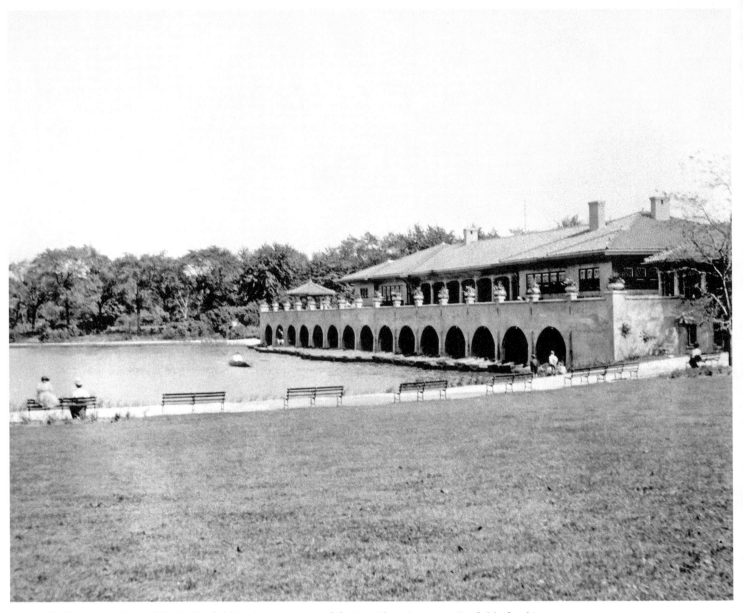

Originally known as Central Park, Garfield Park was re-named for President James A. Garfield after his assassination in 1881. The 185-acre park included a pavilion and lagoon, pictured here in 1908.

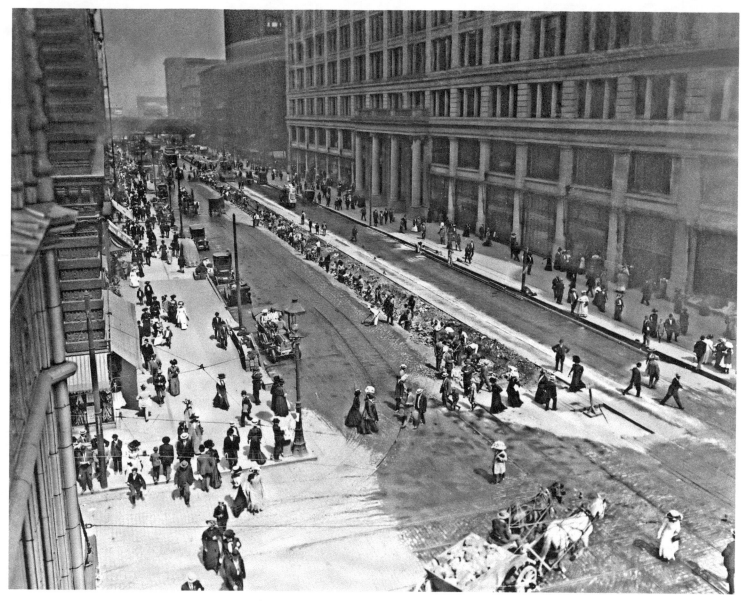

Men dig new streetcar tracks in State Street in the Loop in 1909. The entrance to Marshall Field's Department Store is visible to the right.

An interior view of Holy Name Cathedral, 735 North State Street in 1909. The Sanctuary Panels of the Holy Name are above the cathedra or bishop's throne. These five bronze panels by Attilio Selva represent the Holy Name of Jesus.

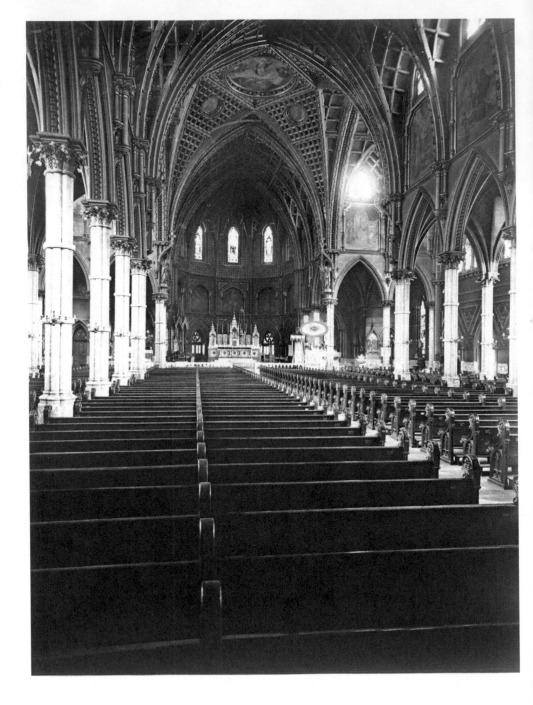

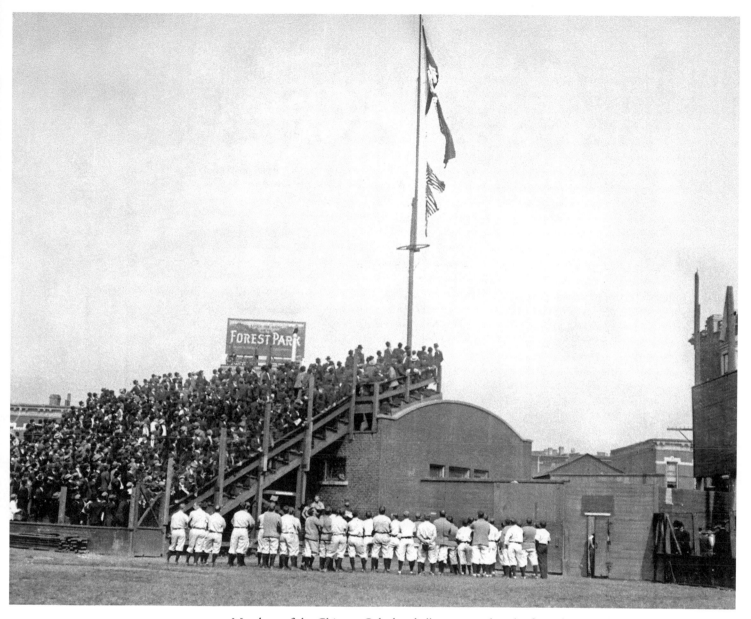

Members of the Chicago Cubs baseball team stand at the flagpole at West Side Grounds during a pennant-raising ceremony in 1909. The park was located between West Polk Street, South Wolcott Avenue, West Taylor Street, and South Wood Street in the Near West Side. The Cubs won the World Series in 1907 and in 1908, but the team has not won the Series again since that year.

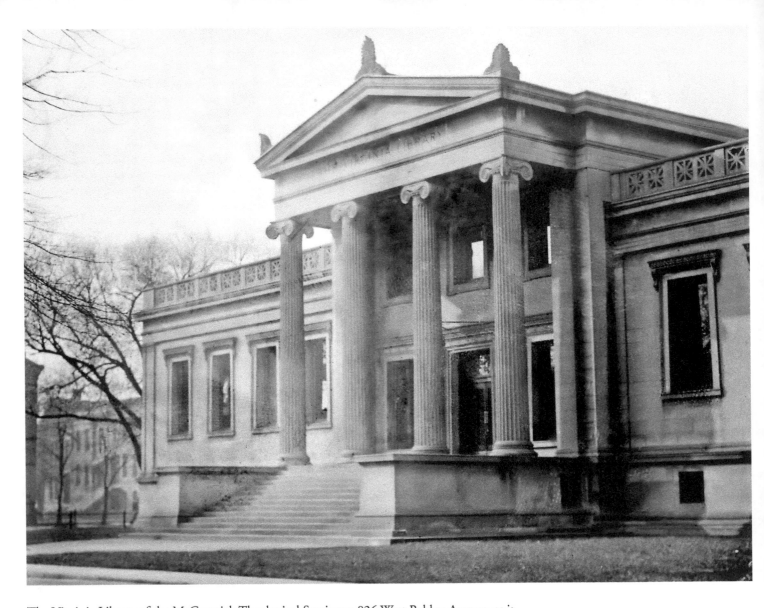

The Virginia Library of the McCormick Theological Seminary, 826 West Belden Avenue, as it appeared in 1909. Cyrus H. McCormick, a zealous Presbyterian, played a key role in moving the Presbyterian Theological Seminary of the Northwest to Chicago from Indiana. After Cyrus's death in 1884, the institution was renamed in his honor. The library, completed in 1895, was the gift of his wife and named in honor of their daughter.

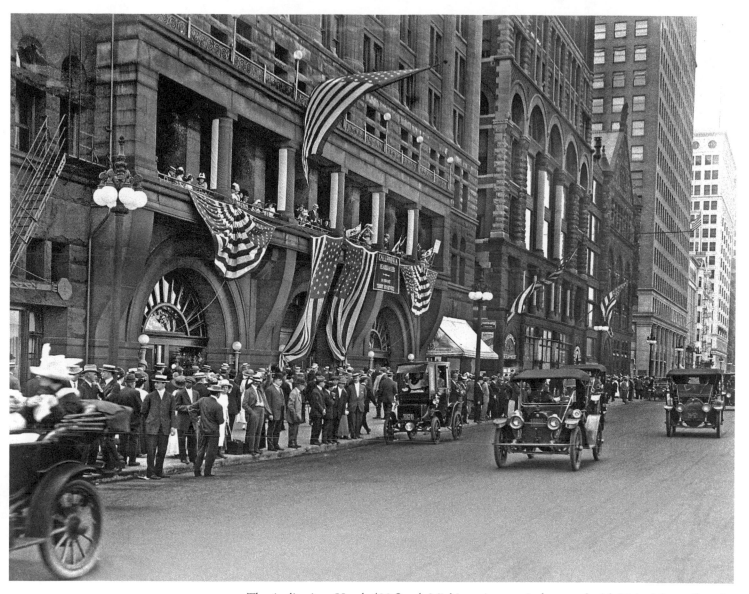

The Auditorium Hotel, 430 South Michigan Avenue, is decorated with United States flags for the arrival of Theodore Roosevelt on June 17, 1912. Roosevelt was in Chicago for the Republican National Convention, where he hoped to recapture the nomination of his party from incumbent President William Howard Taft. He failed in this attempt, but won the nomination of the Progressive Party two months later.

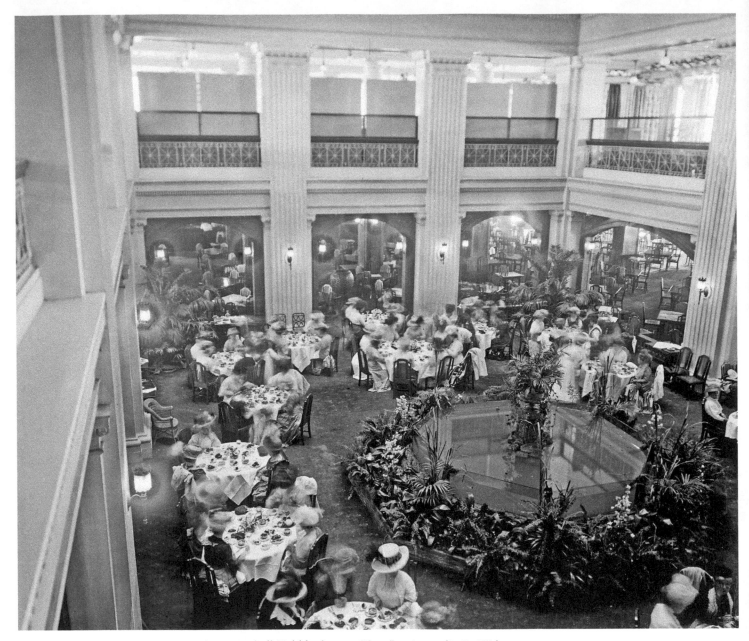

An innovator among American retailers, Marshall Field had many "firsts" to its credit. Its Walnut Room was the first dining room in an American retail store. Here, shoppers enjoy a meal in 1909.

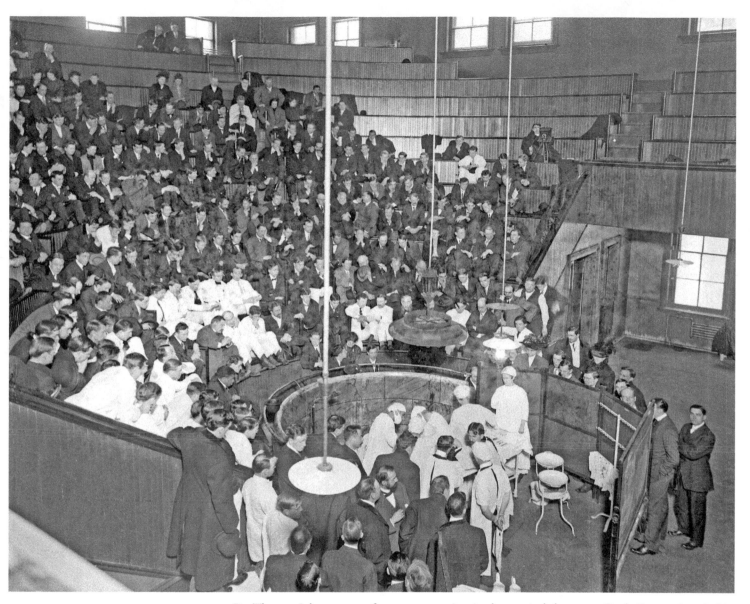

Dr. Thomas Johnnesco performs an operation in the surgical theater at Cook County hospital in 1910. Cook County Hospital has long been a leader in medical education. The hospital began the first internship program in the United States in 1866. Interns, who worked without pay, were chosen by competitive examination.

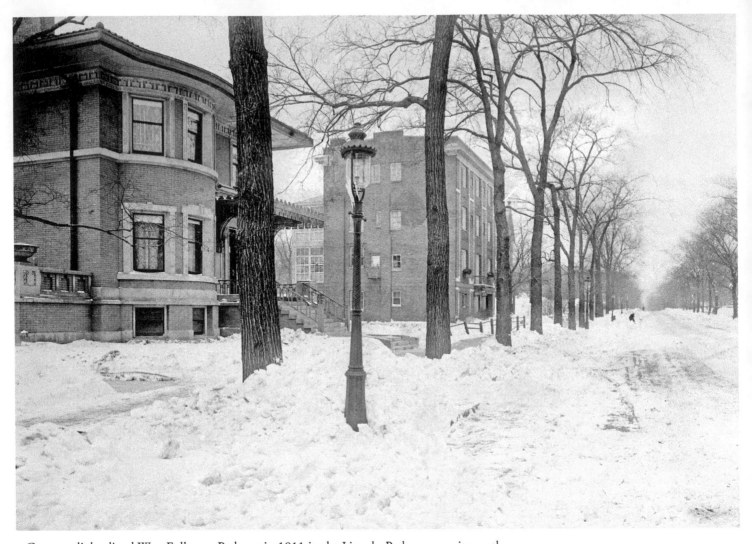

Gas streetlights lined West Fullerton Parkway in 1911 in the Lincoln Park community on the Near North Side. Although the Chicago Fire destroyed many homes south of Fullerton, post-fire construction brought new residents to the area. Growth continued in the new century.

A sailboat appears in the harbor on Lake Calumet in 1913. The lake's swampy marsh was filled and developed by industry in the 1880s. The Pullman Car Company was located on Lake Calumet's western edge.

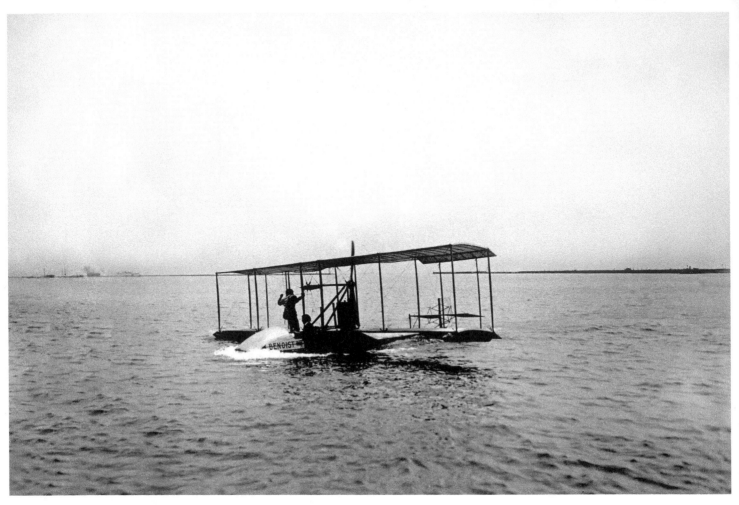

Aviator Anthony Jannus drives an aeroboat on Lake Michigan at Grant Park on July 7, 1913.

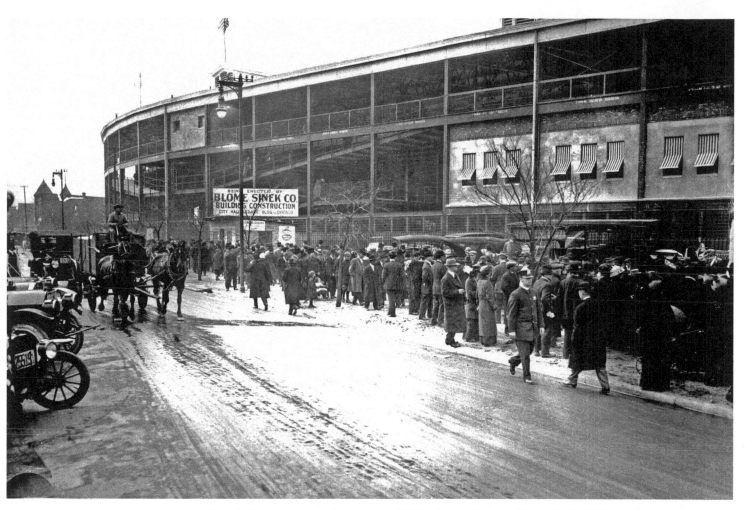

Crowds line up outside the newly built Weeghman Park on May 14, 1914. The ballpark was home to Charlie Weeghman's Federal League team, the Chicago Whales. When the Federal League folded two years later, Weeghman purchased the National League Cubs. Cubs Park was renamed Wrigley Field in 1926 in honor of the team's owner since 1920, William Wrigley, Jr.

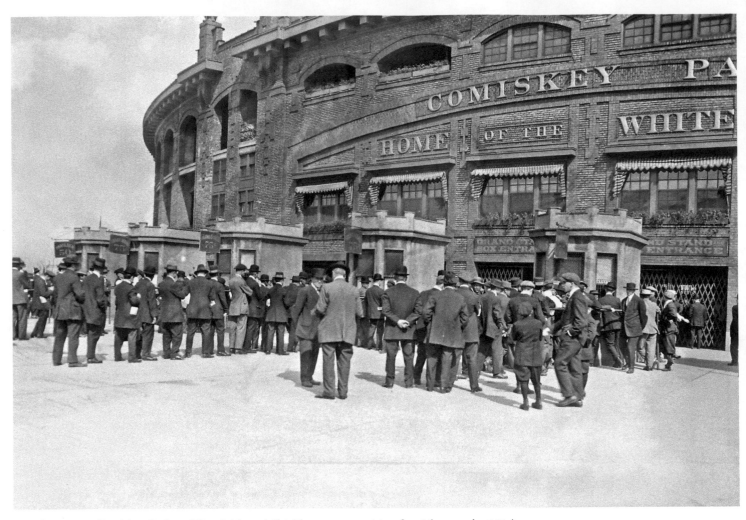

Fans line up at Comiskey Park, at West 34th and Shields avenues, waiting for tickets to the 1914 Chicago City Series. The White Sox and Cubs have met only once in a World Series, which the White Sox won in 1906. Since then, the teams have occasionally played a City Series for "bragging rights" only. This park was the home of the White Sox from 1910 until 1990, when a new park was built across the street.

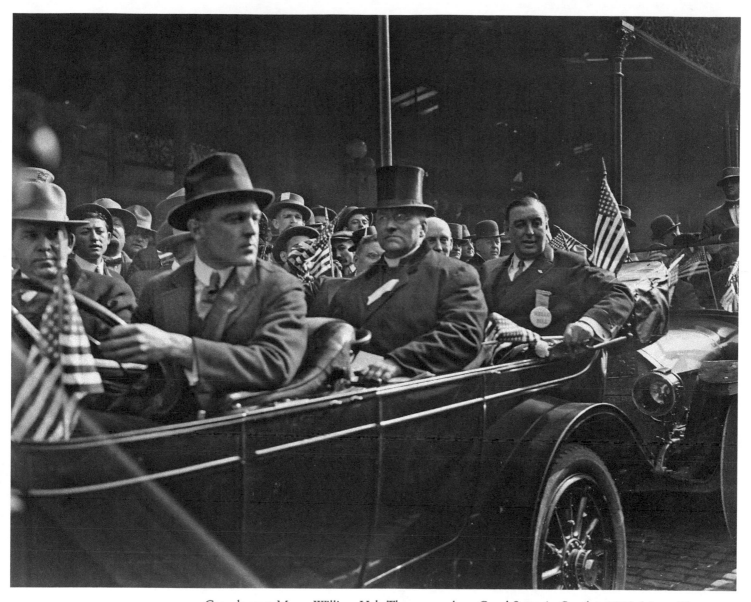

Crowds greet Mayor William Hale Thompson along Canal Street in October 1915. Mayor Thompson began his first term as mayor that year. He ran again successfully in 1919, but declined to run for reelection in 1923. Thompson regained the office for one more term in 1927. As of 2009, he was the last Republican to be mayor of Chicago.

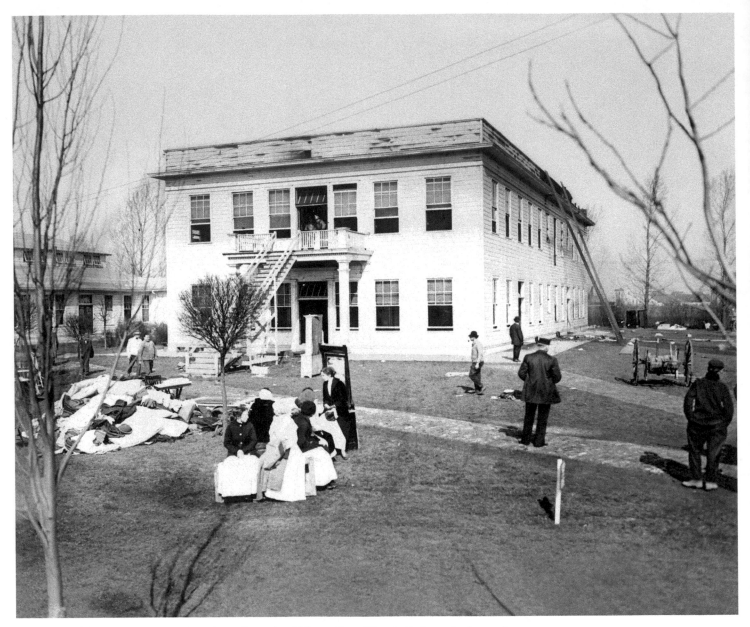

Residents of the Dunning Mental Institute (later the Chicago State Hospital) sit on the lawn after a fire in 1915. Dunning, located on Irving Park Road and Narragansett Avenue, was established in 1851 as a poorhouse and mental asylum. It later served as a tuberculosis sanatorium.

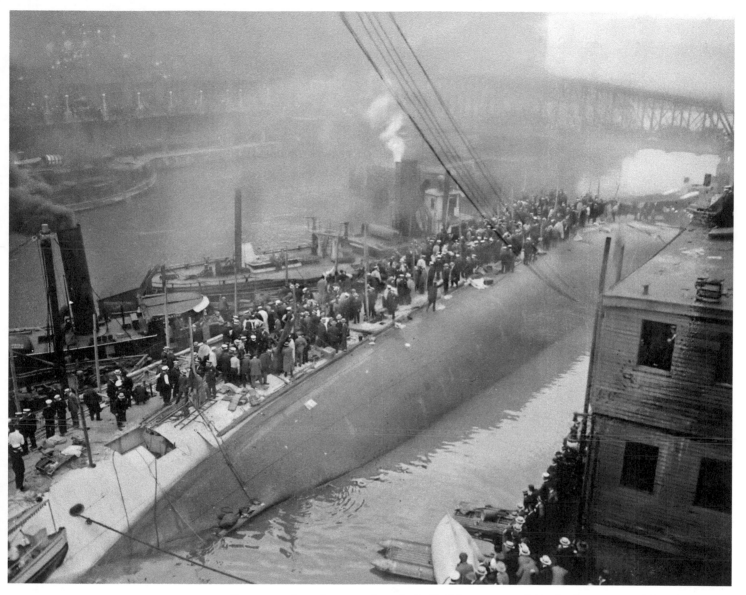

Rescuers and survivors stand on the hull of the overturned *Eastland* steamer on July 24, 1915. At seven-twenty-eight that morning, the excursion steamer rolled over in the Chicago River while still moored in dock between LaSalle and Clark streets. On board were approximately 2,500 Western Electric employees and family members, on their way to the company picnic in Michigan City, Indiana. Of these, 844 persons perished, the largest death toll in any Chicago disaster.

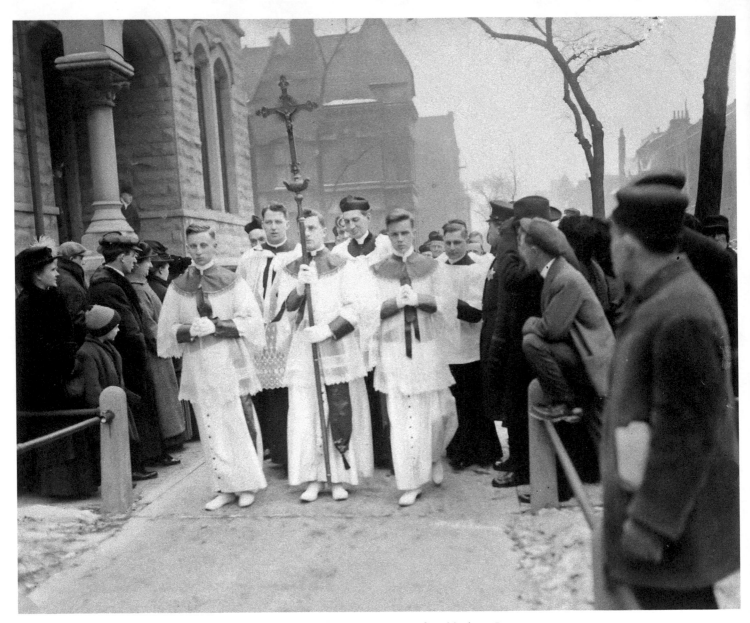

A procession of priests at Holy Name Cathedral at the installation ceremony of Archbishop George Mundelein in February 1916. Previously auxiliary bishop of Brooklyn, he succeeded Archbishop James Edward Quigley. In 1924, Archbishop Mundelein was elevated to Cardinal, the first in the history of the Chicago diocese. He served as Cardinal until his death in 1939.

The Moody Tabernacle at North Avenue and North Clark Street, under construction in 1916, held 5,000 worshipers. It replaced the Moody Church on North LaSalle Street, founded by Dwight Moody in 1864 as the Illinois Street Church.

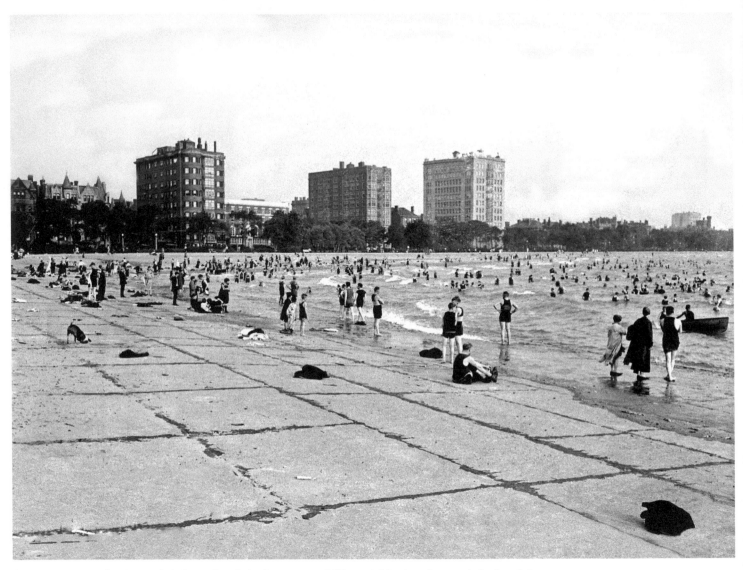

Swimmers enjoy the day at Oak Street Beach in August 1916. The neighborhood around the beach is known as Streeterville after George Streeter, who claimed squatter's rights to the sandbar after running his boat aground there. His claims to the land finally resulted in a court battle, ending in 1918, when his claims were ruled invalid.

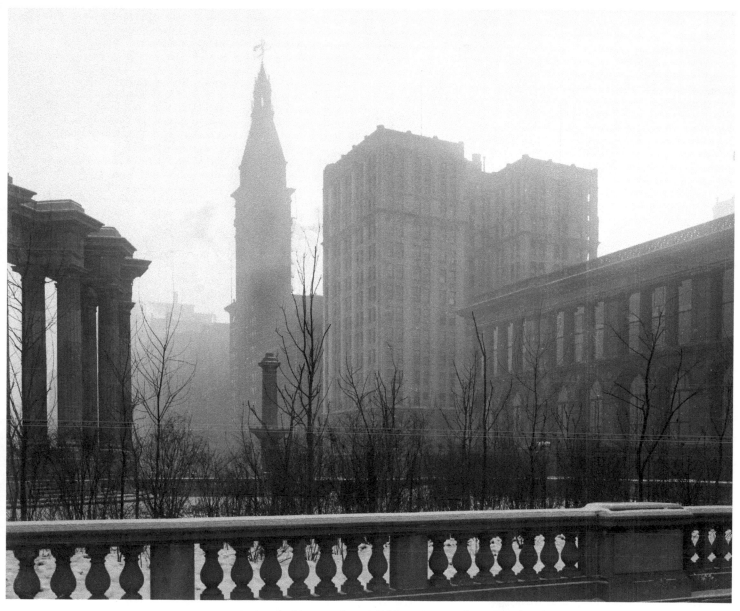

A view looking south on Michigan Avenue from Grant Park in 1916 shows the Chicago Public Library on the right with the Montgomery Ward Tower in the background. A portion of the peristyle, recently re-created in Millennium Park, can be seen on the left.

This view of LaSalle Street looking north from the Board of Trade in 1916 shows several important buildings of that era. On the left is the Gaff Building at the corner of Quincy and LaSalle: the Illinois Trust and Savings Bank is on the right, next to the Rookery Building.

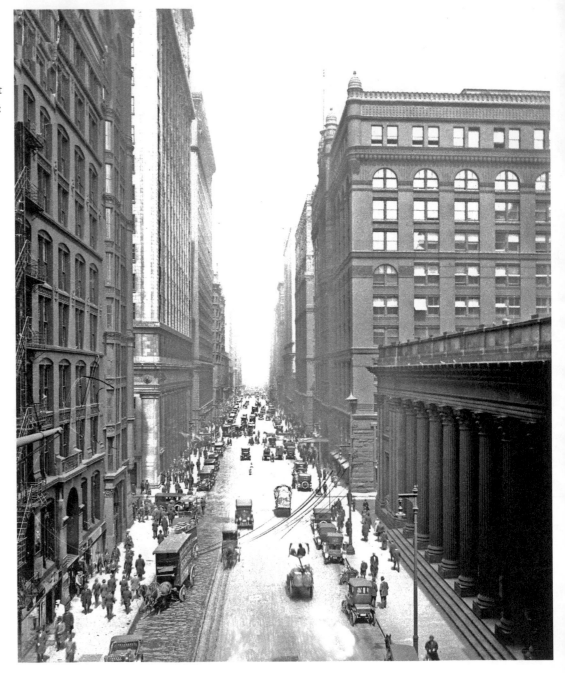

Army recruiters set up in Grant Park in 1917.

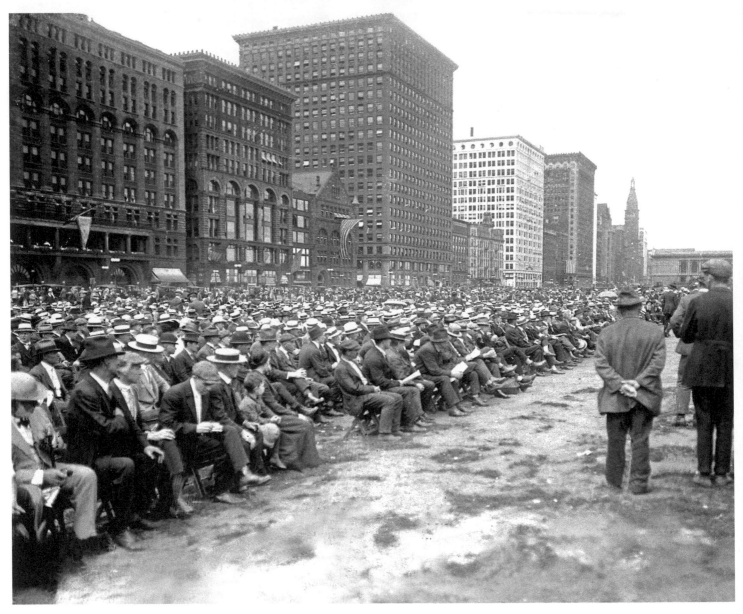

A crowd attends an open-air meeting at Grant Park in 1917. The buildings seen on South Michigan Avenue are, from left to right, the Auditorium, the Studebaker Theater, the Chicago Club Building, and the Chicago Exchange.

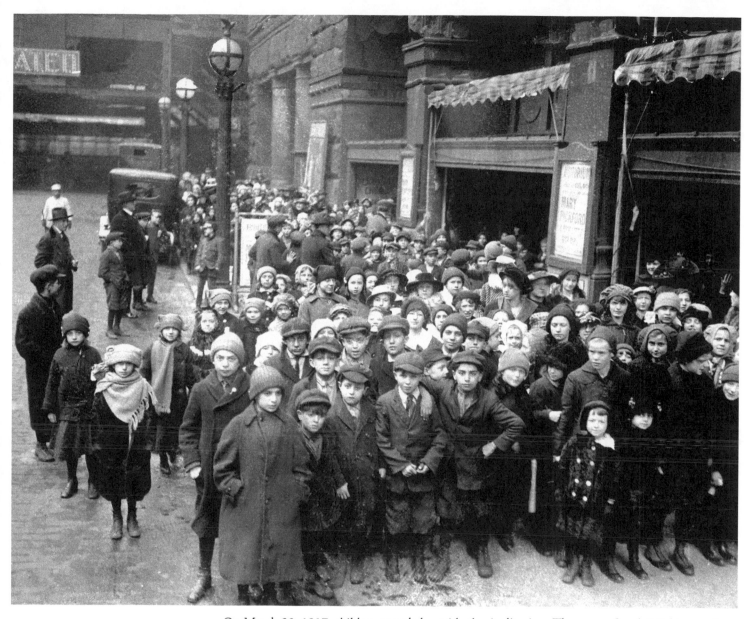

On March 23, 1917, children crowded outside the Auditorium Theater on South Michigan, where *Poor Little Rich Girl*, starring Mary Pickford, was playing.

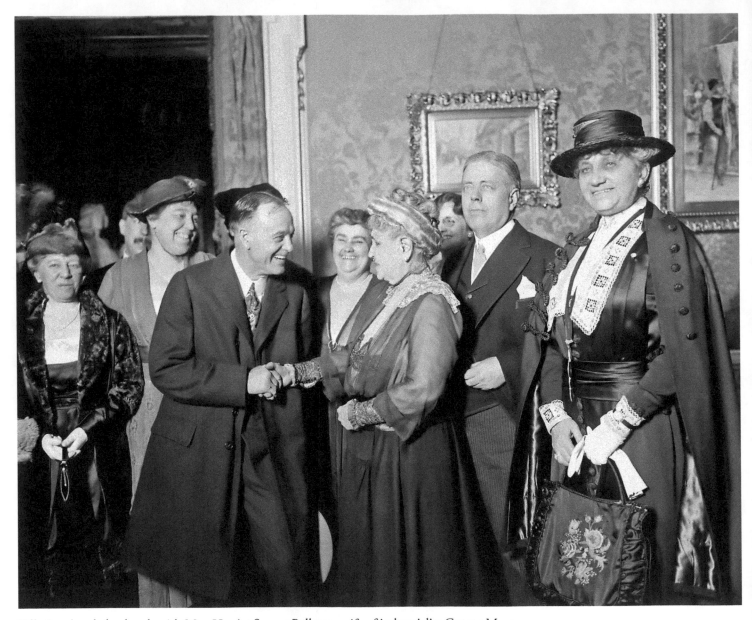

Billy Sunday shakes hands with Mrs. Harriet Sanger Pullman, wife of industrialist George M. Pullman, in 1917. Earlier in his life, Sunday played professional baseball with the Chicago White Stockings. After his conversion at Pacific Garden Mission, he became one of the country's best-known evangelists.

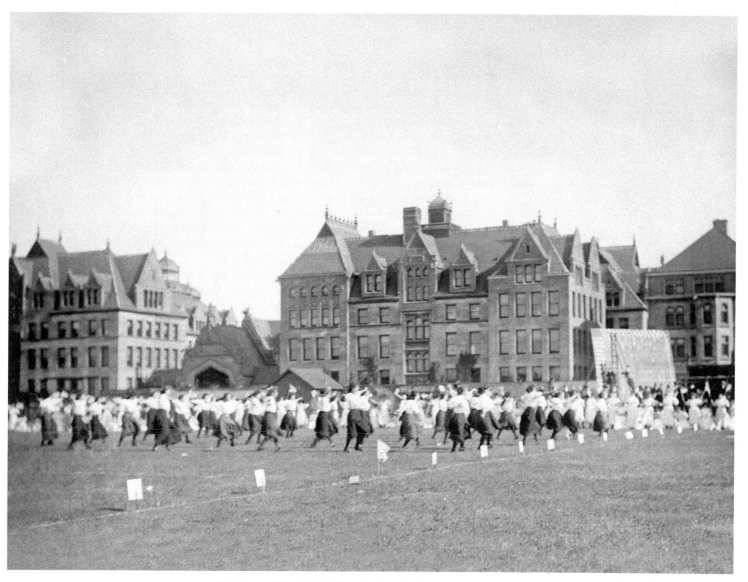

Girls from Wendell Phillips High School exercise before a track meet at the athletic field at Marshall Field (renamed Stagg Field in 1913) at East 57th Street and South Ellis Avenue on the University of Chicago campus.

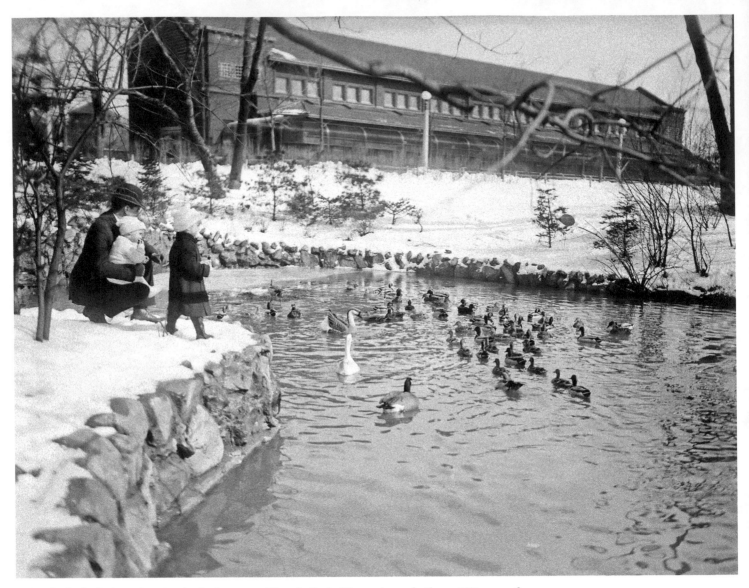

A family feeds ducks swimming in the lagoon at Lincoln Park. The park was built on 120 acres of swamp land, with a ten-mile ditch dug to drain the lowlands and create the lagoon. At first called Lake Park, the development was renamed Lincoln Park after the assassination of President Lincoln in 1865. The park and surrounding neighborhood were modeled after New York's Central Park as well as Haussman's Park and Boulevard system in Paris.

BETWEEN THE WORLD WARS

(1918–1940)

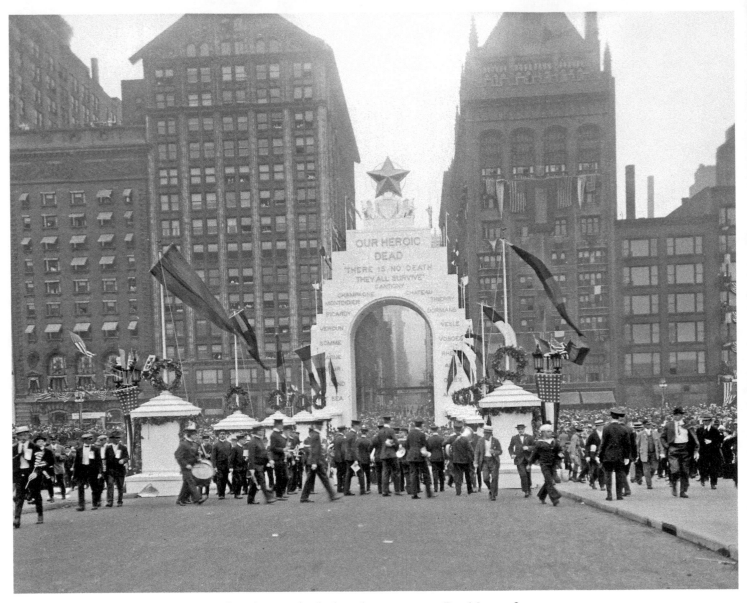

Participants in the 1918 Labor Day Parade gather at an arch-shaped monument at East Monroe Street and South Michigan Avenue.

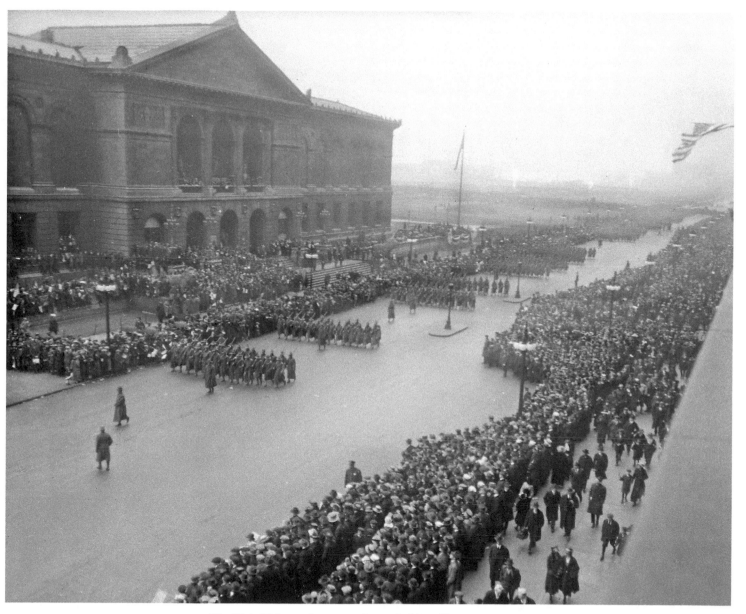

The Third Liberty Loan parade was held in Chicago in 1918 to raise money for the war. Despite the flu epidemic spreading throughout the country, the Chicago health department gave the okay for this huge public gathering. Parade goers were instructed to shed clothing, rub their bodies dry, and take a laxative after returning home to prevent contracting the disease.

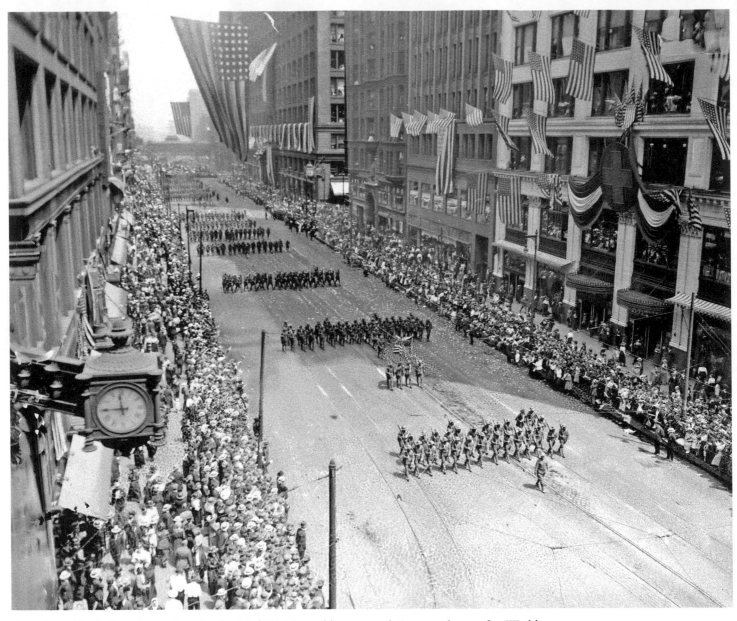

Crowds on North State Street cheer for the 33rd Division soldiers upon their return home after World War I.

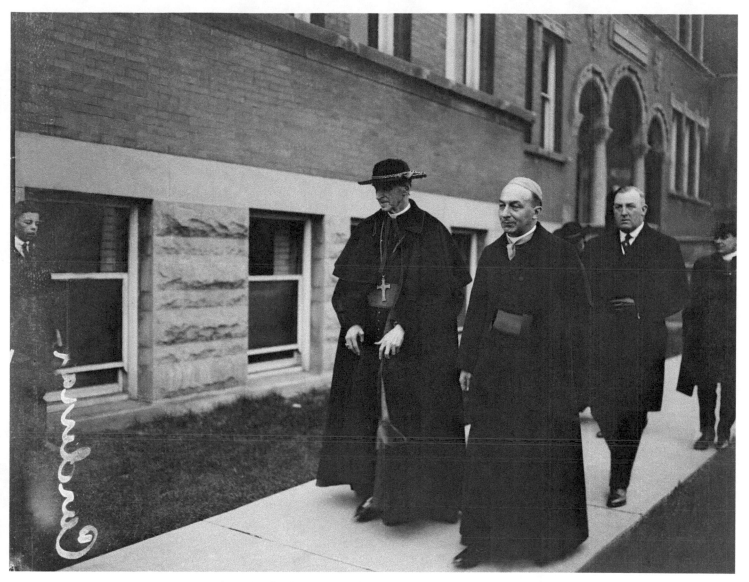

Belgian Cardinal Désiré Joseph Mercier (at left) met with Archbishop George W. Mundelein on a trip to Chicago in 1919. Cardinal Mercier, who was briefly held under house arrest during World War I for his opposition to German occupation, was raising money to rebuild postwar Belgium.

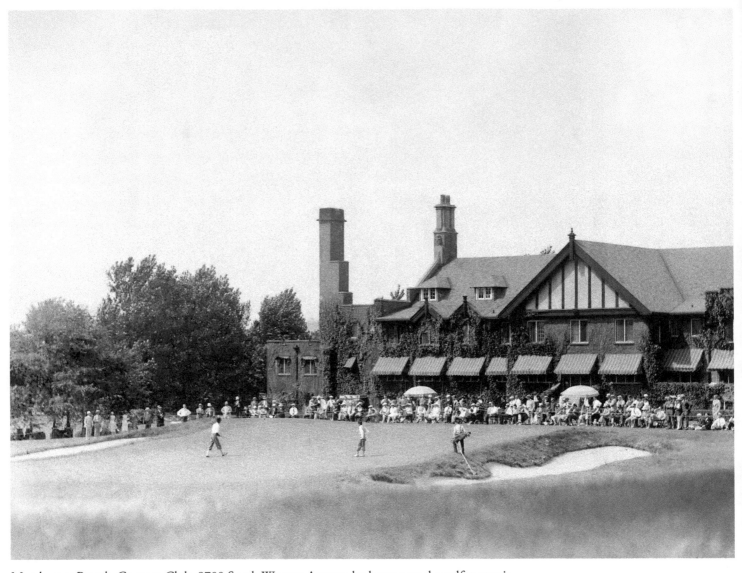

Members at Beverly Country Club, 8700 South Western Avenue, look out over the golf course in 1919. In 1918, Scottish-born course designer Donald Ross was retained to redesign the course. Its 18 holes stretch from 86th to 91st Street along Western Avenue.

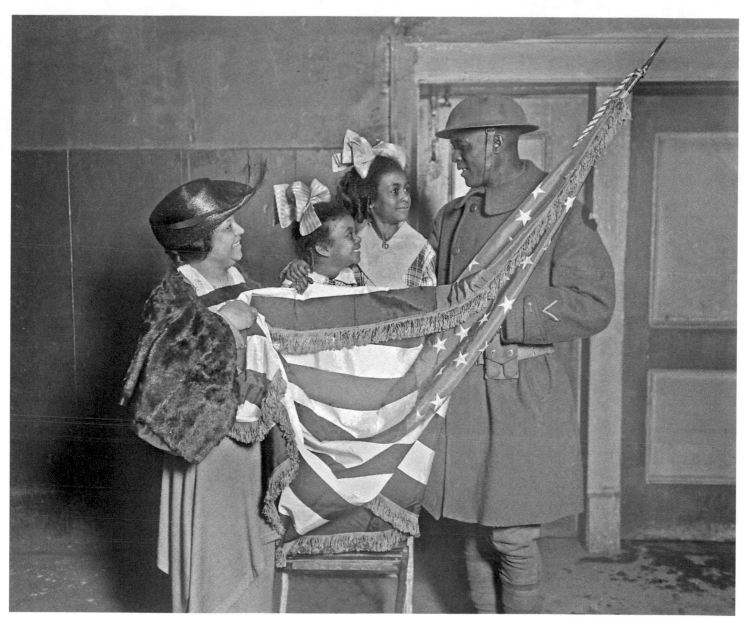

Sergeant John Edmondson, of the Illinois Eighth Regiment, with his wife and daughters in 1919. The only regiment to be entirely commanded by African-Americans, the Fighting Eighth served with distinction in France during World War I, suffering many casualties.

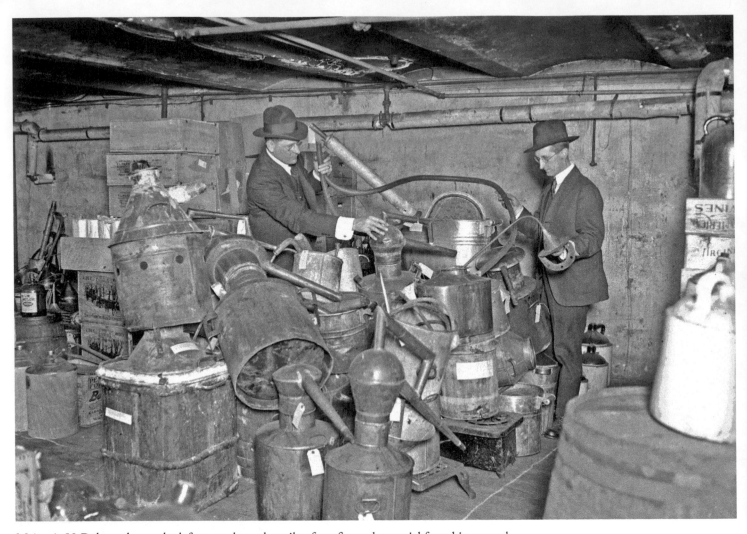

Major A. V. Dalrymple, on the left, sorts through a pile of confiscated material found in a search during prohibition.

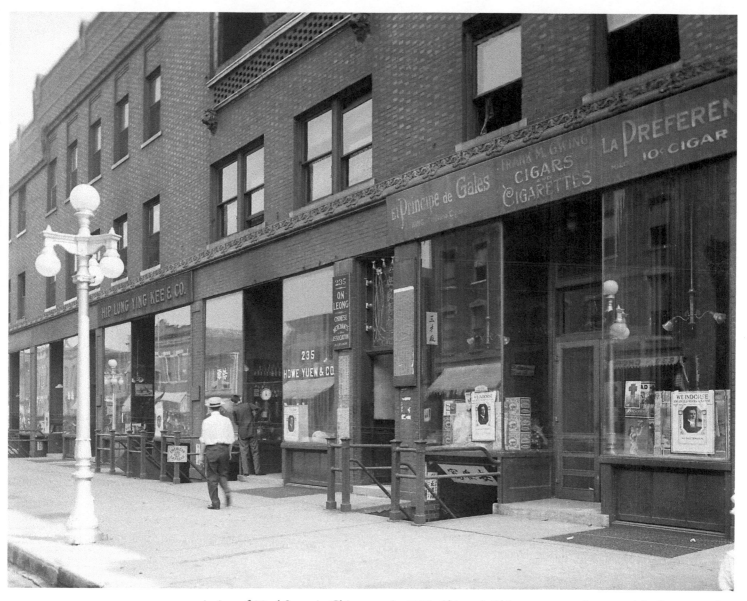

A view of 22nd Street in Chinatown in 1928. Chicago's Chinese community was originally centered in the Loop, but moved to this area in Armour Square around 1912.

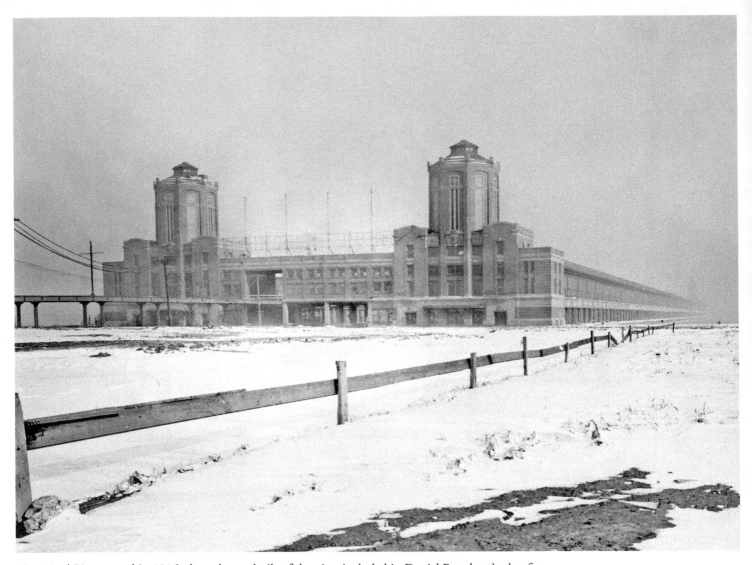

Municipal Pier opened in 1916, the only one built of the piers included in Daniel Burnham's plan for harbor development. When opened, it was the world's largest freight and recreational pier at 292 feet wide and 3,000 feet long. In 1927, it was renamed Navy Pier in honor of World War I veterans.

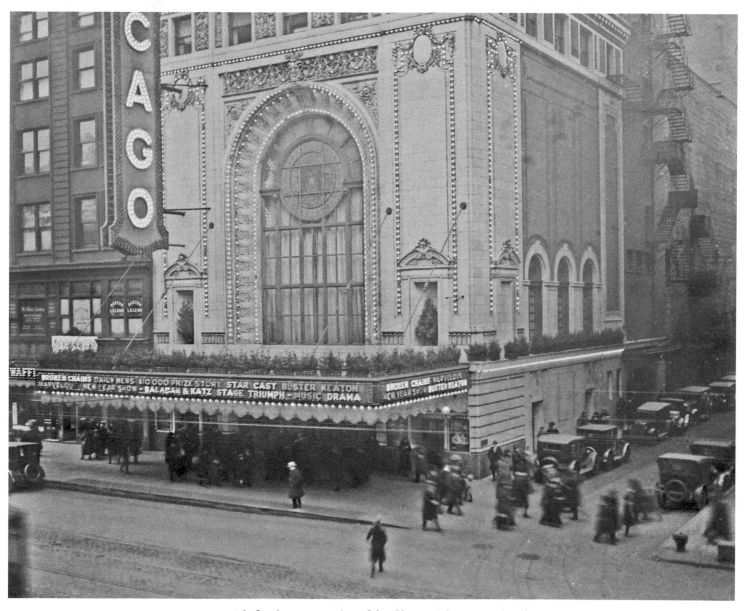

Ads for the opening day of the Chicago Theatre on October 26, 1921, invited patrons to view its "indescribable splendor." In its early years, the theater featured both film and live performances, including *Broken Chains,* seen here on the marquee in 1923. The Chicago Theatre, with its 3,800 seats, was the flagship of the Balaban and Katz theatre chain. Its six-story "C-H-I-C-A-G-O" sign is a landmark.

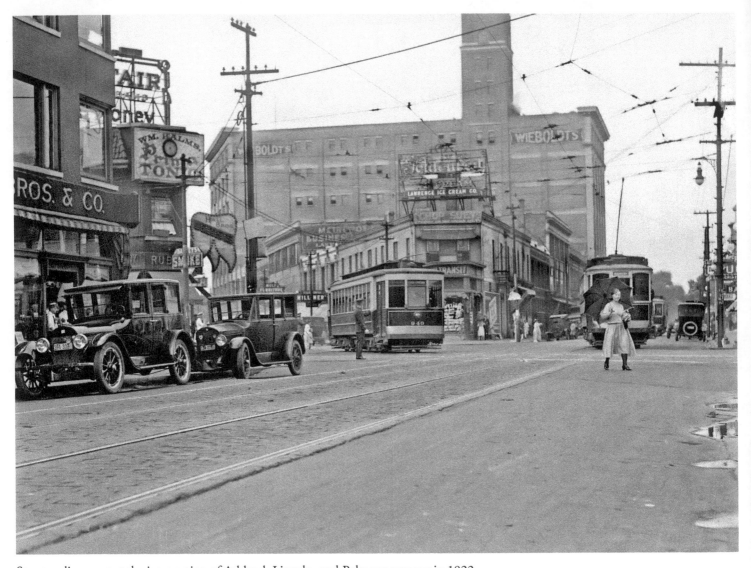

Streetcar lines met at the intersection of Ashland, Lincoln, and Belmont avenues in 1922.

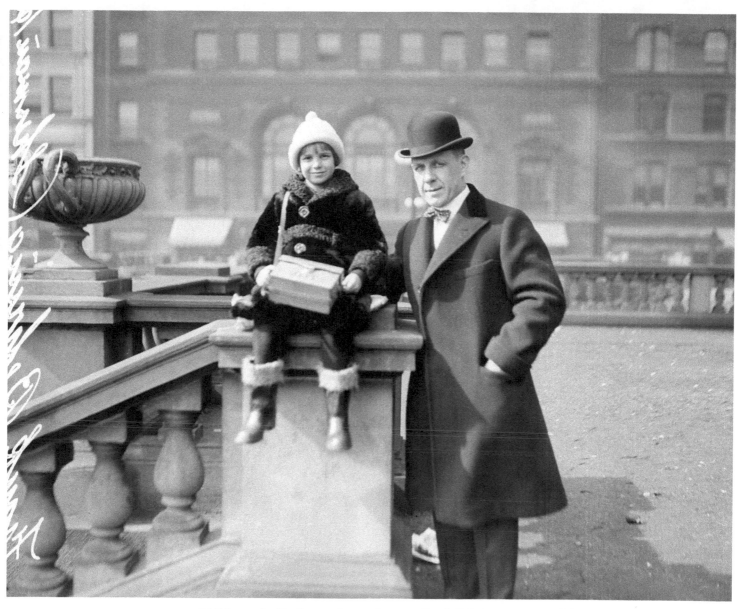

Child actor Jackie Coogan is seated next to Frank Behring, manager of the Hotel Sherman, outside the Art Institute in 1923.

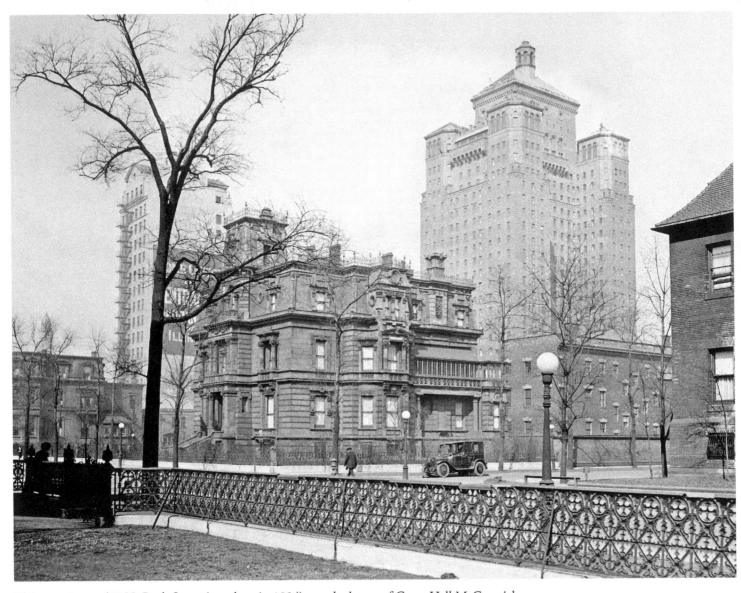

This mansion at 675 N. Rush Street (seen here in 1924) was the home of Cyrus Hall McCormick. After he died in 1884, other members of the McCormick family occupied the house until 1941.

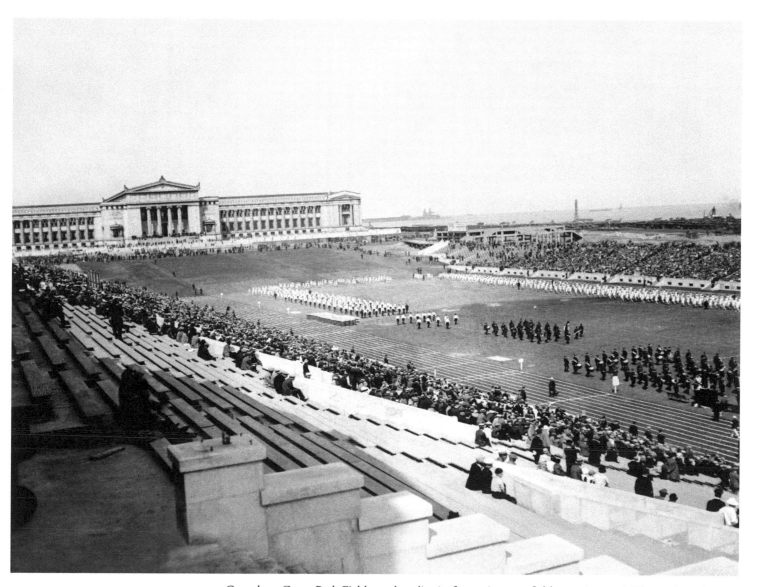

Crowds at Grant Park Field watch police in formation at a field meet in 1924. The stadium had its official opening on October 9, 1924, the 53rd anniversary of the Chicago Fire. It was renamed Soldier Field shortly after.

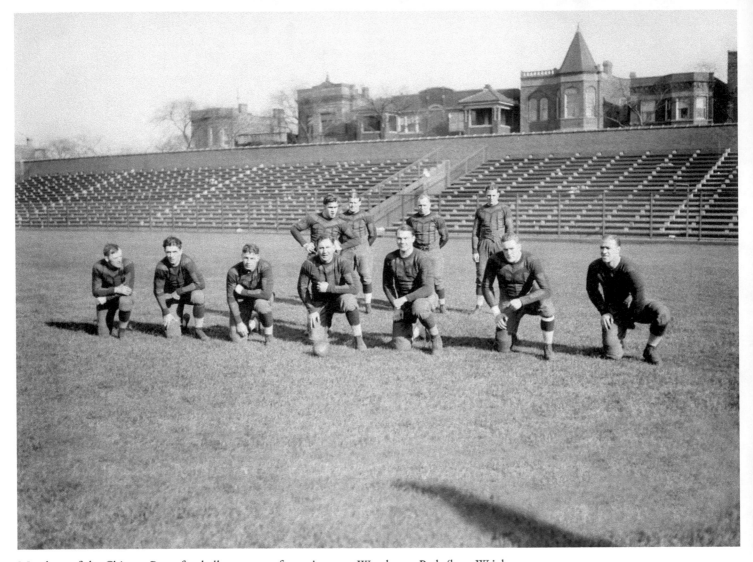

Members of the Chicago Bears football team pose for a picture at Weeghman Park (later Wrigley Field) in 1925. Included are Bill Fleckenstein, Harold "Red" Grange, George Halas, Frank Hanny, Ed Healy, Jim McMillen, Richard Murray, Joe Sternman, George Trafton, and Laurie Walquist. The Bears, whose name was a reflection of the baseball Cubs, played here until 1970 when they moved to Soldier Field.

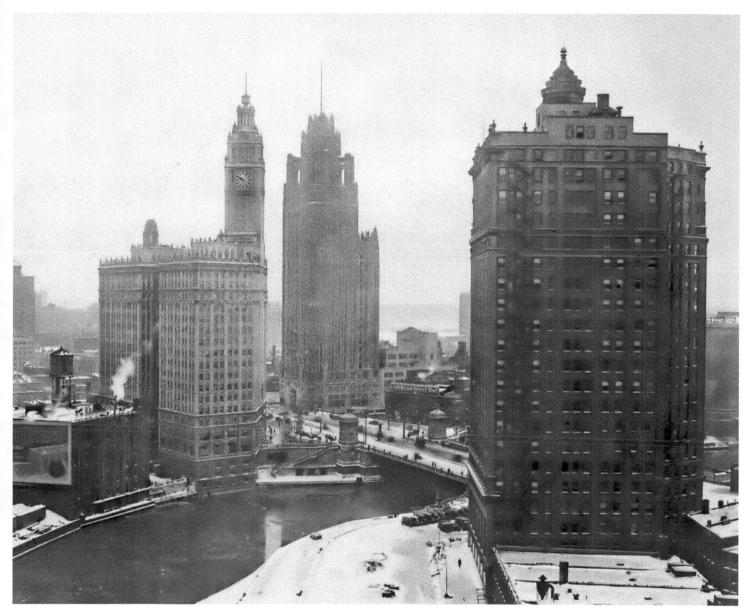

Wacker Drive in 1926 shows a view of three great landmarks: the Tribune Tower, the Wrigley Building, and the Jewelers Building (now known as the 35 East Wacker Drive Building). All three buildings still stand.

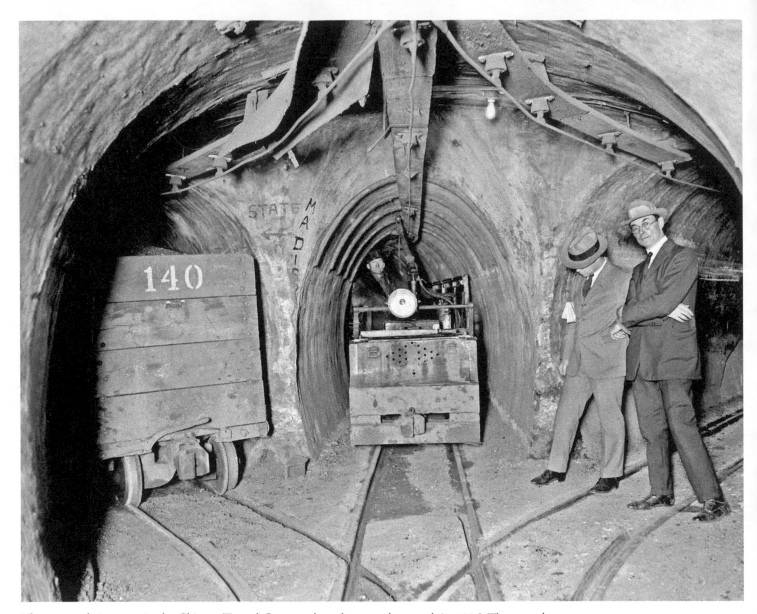

Three tunnels intersect in the Chicago Tunnel Company's underground network in 1926. The tunnel system was planned in 1899 to house telephone cables, but the tunnels were large enough to include two-foot gauge railroad tracks. By 1906, freight cars were in service, delivering merchandise and coal to freight stations, warehouses, office buildings, and stores.

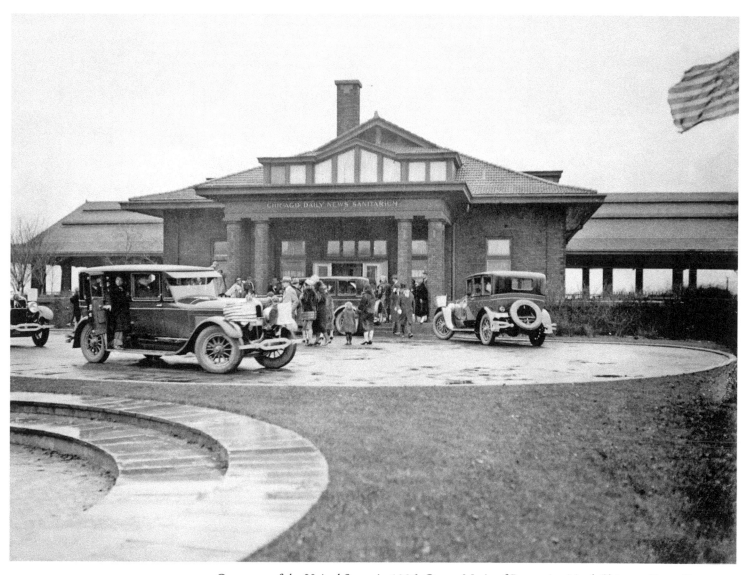

On a tour of the United States in 1926, Queen Marie of Romania visited Chicago. One of her stops was the Daily News Fresh Air Sanitarium at Fullerton and the Lake. The former sanatorium building is now home to the Theater on the Lake.

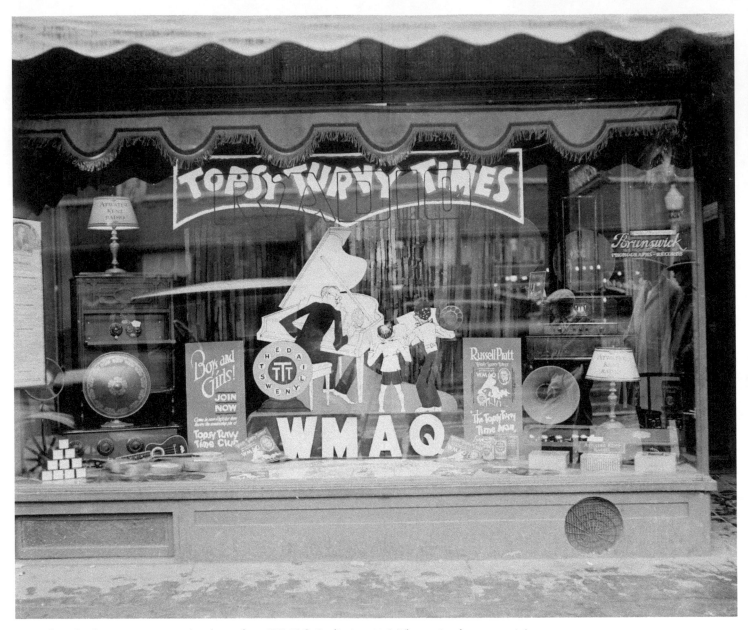

A window display promotes popular shows from WMAQ Radio in 1926. The station began as a joint effort between the Chicago Daily News and the Fair Department Store, although the Fair's involvement was short-lived. The first broadcast under the WMAQ call letters was on October 2, 1922.

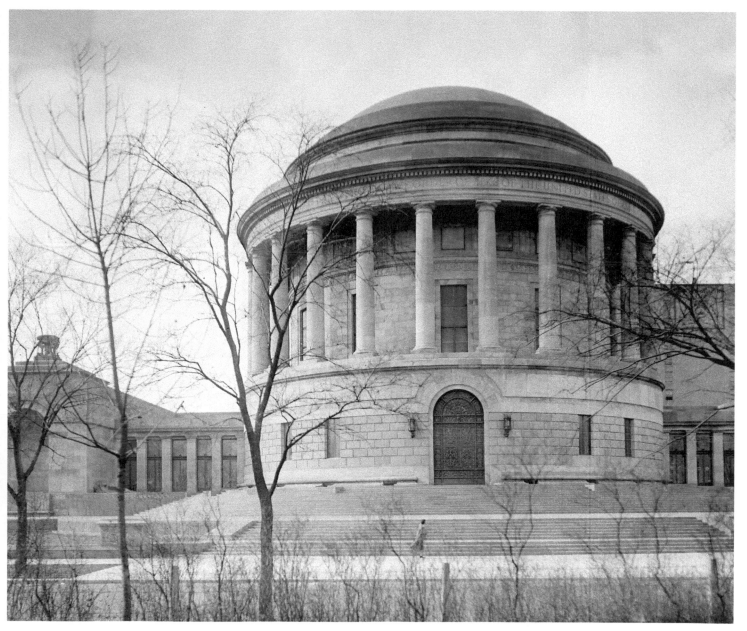

The Elks National Memorial Building, 2750 North Lakeview Avenue, was erected in 1926 to honor those Elks who lost their lives in World War I.

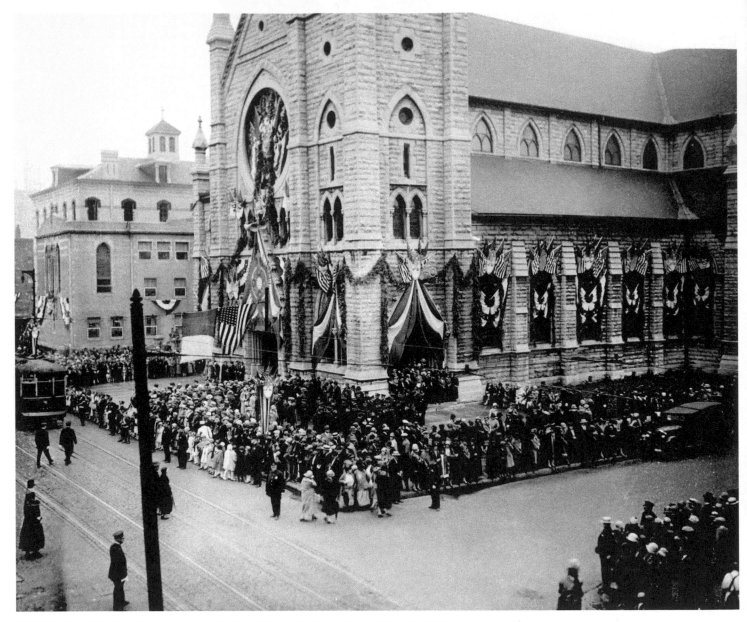

Faithful Catholics line the streets outside Holy Name Cathedral in 1926 at the 28th International Eucharistic Congress. This congress was the first held in the United States.

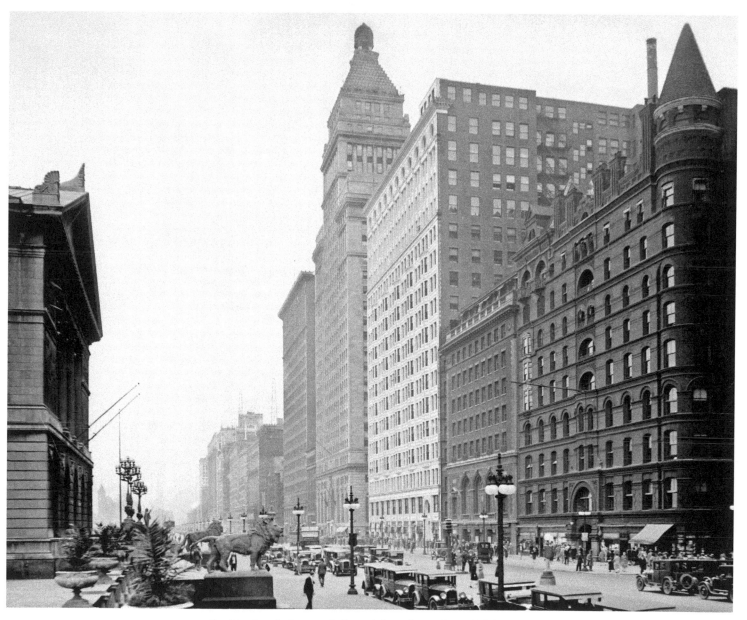

In this view facing south from Adams Street down Michigan Avenue in 1927, the Pullman Building, Orchestra Hall, and the Railway Exchange are visible on the right. The north face of the Art Institute is on the left.

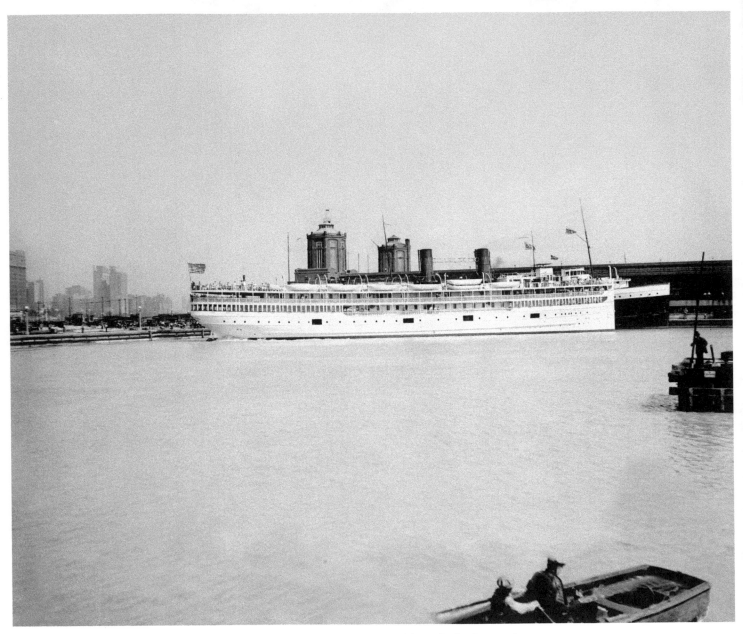

The steamer *Theodore Roosevelt* on Lake Michigan in 1927. Navy Pier is visible in the background.

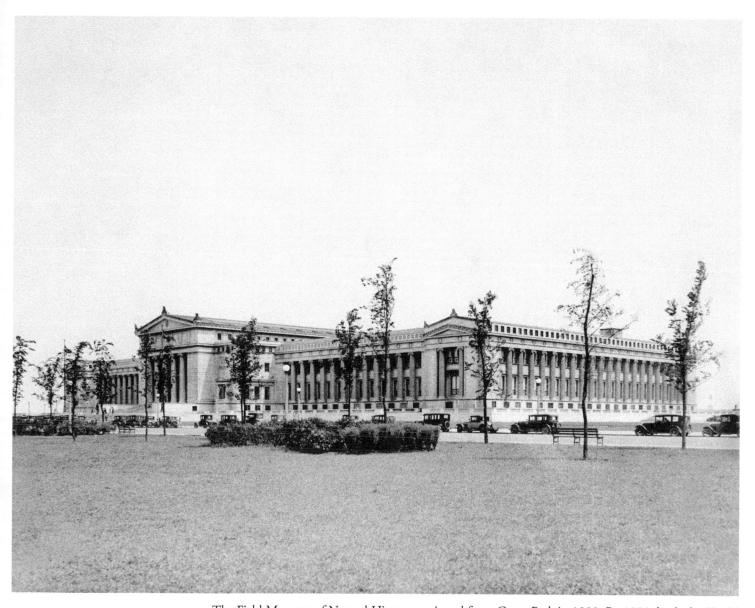

The Field Museum of Natural History, as viewed from Grant Park in 1928. By 1930, both the Shedd Aquarium and Adler Planetarium would join this museum at the south end of the park. The museums were included in the design of the Century of Progress.

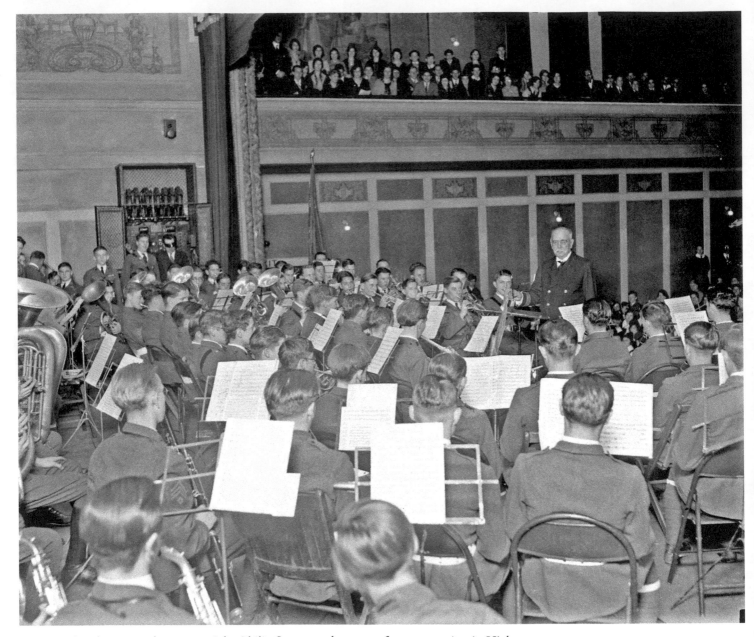

American bandmaster and composer John Philip Sousa conducts a performance at Austin High School, 5417 West Fulton Street, in 1928.

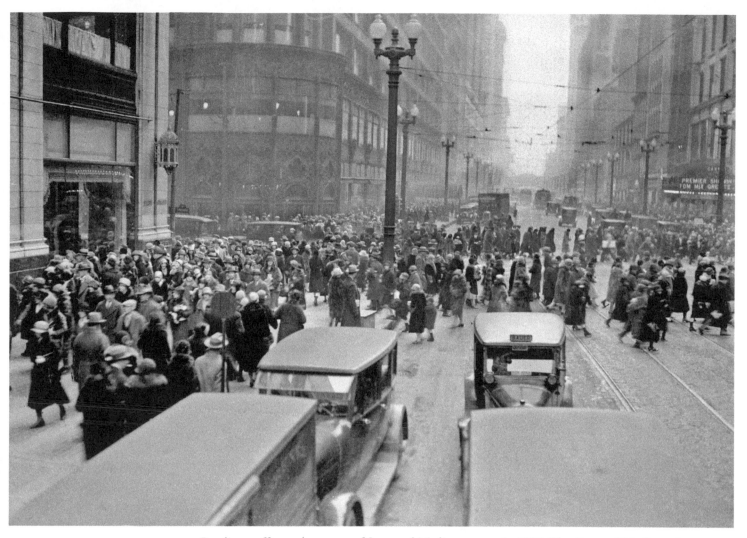

Bustling traffic on the corner of State and Madison streets in 1927. The Carson Pirie Scott department store is visible in the background on the left. This landmark structure, the first part of which was built in 1899 as the Schlesinger and Mayer store, is one of architect Louis Sullivan's masterworks.

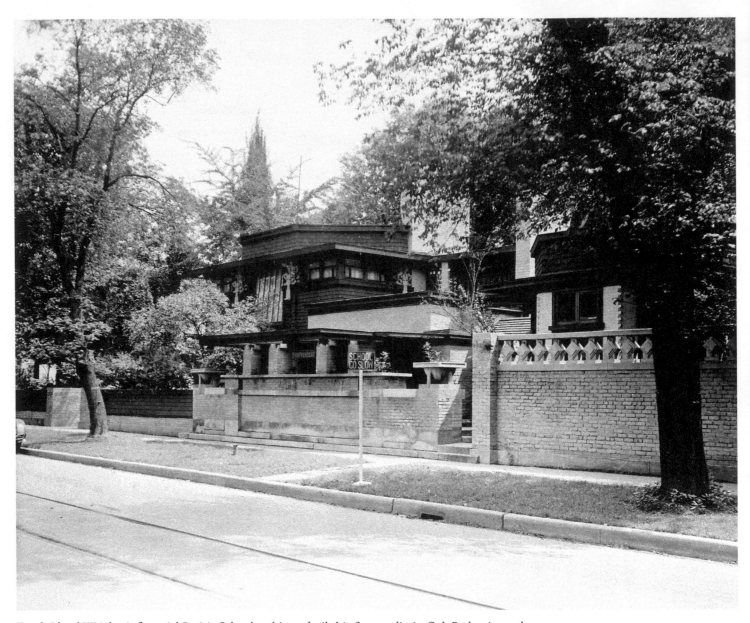

Frank Lloyd Wright, influential Prairie School architect, built his first studio in Oak Park, pictured here in 1926. In Chicago, Wright worked first as a draftsman for Joseph Lyman Silsbee, and, starting in 1887, for the noted architectural firm Adler & Sullivan. He became chief draftsman before he left in 1893 to begin his own practice.

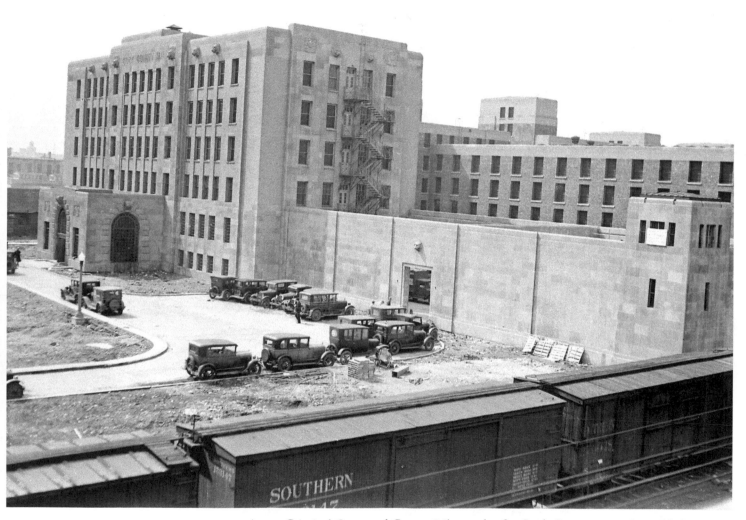

A new Criminal Court and County Jail complex for Cook County opened at 26th Street and California Avenue in 1929.

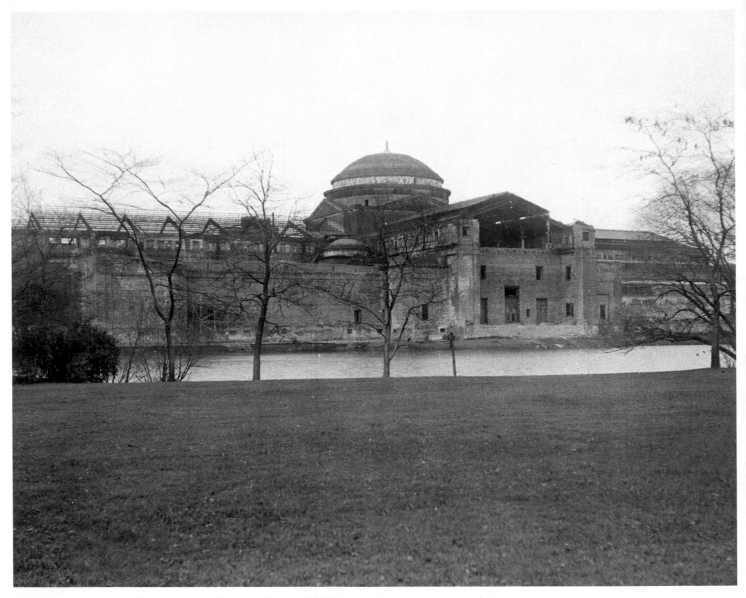

In 1929, reconstruction began to transform the former Field Museum into the Museum of Science and Industry. The exterior was kept as an exact copy of the original Beaux-Arts from when it was the Palace of Fine Arts for the Columbian Exposition. The interior was remodeled in the Art Moderne style, under the direction of architect Alfred Shaw.

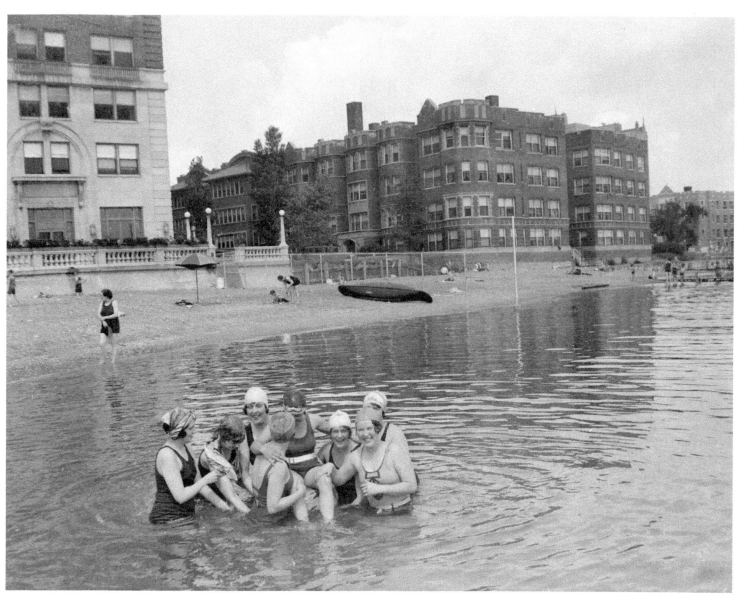

Women enjoy the beach in front of the Edgewater Athletic Club in 1929.

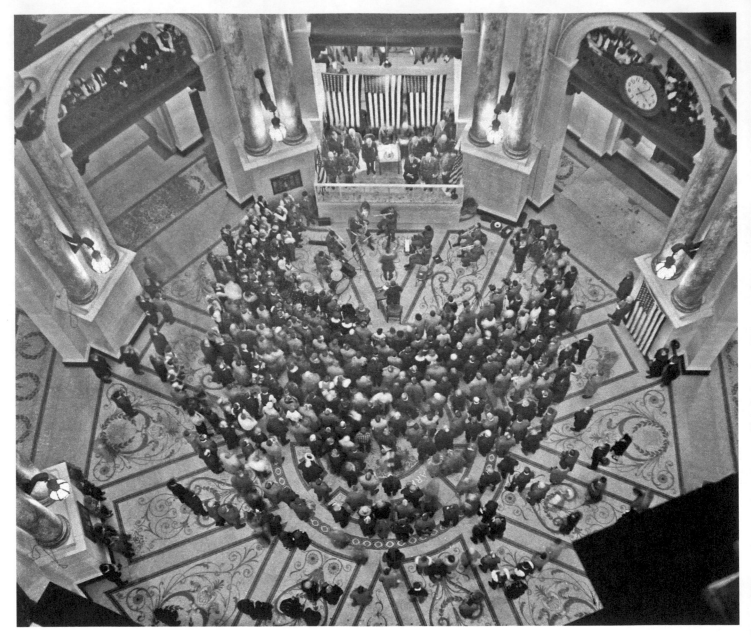

Crowds gather in the Federal Building October 11, 1929, during services marking the 150th anniversary of the death of Polish nobleman and Revolutionary War hero Casimir Pulaski.

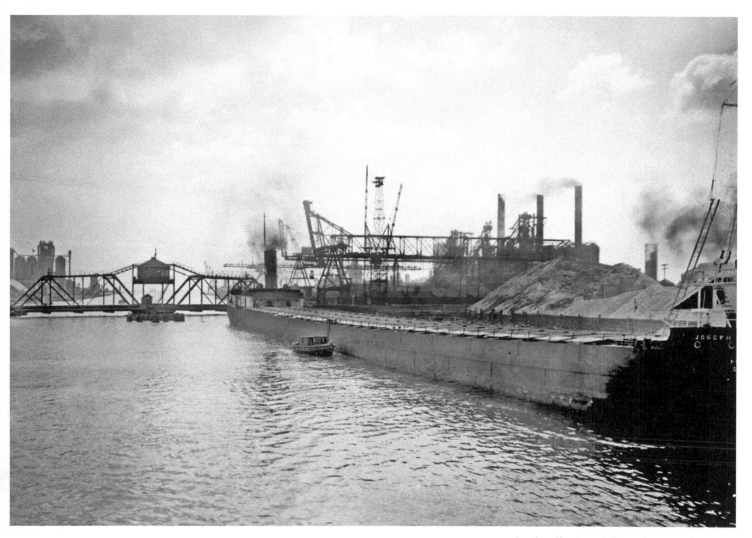

Steel mills viewed from the water in 1929.

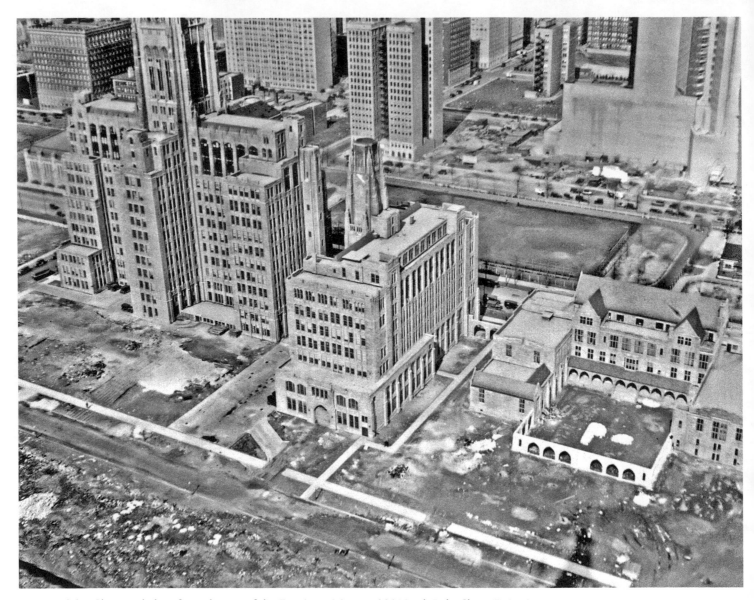

A view of the Chicago skyline from the top of the Furniture Mart at 666 North Lake Shore Drive in 1927. In the 1920s, the four states bordering Lake Michigan had the largest concentration of furniture manufacturers in the country. The American Furniture Mart housed the nation's most important furniture shows. After the building was converted to condominiums in the 1980s, the address was changed to 680 North Lake Shore Drive.

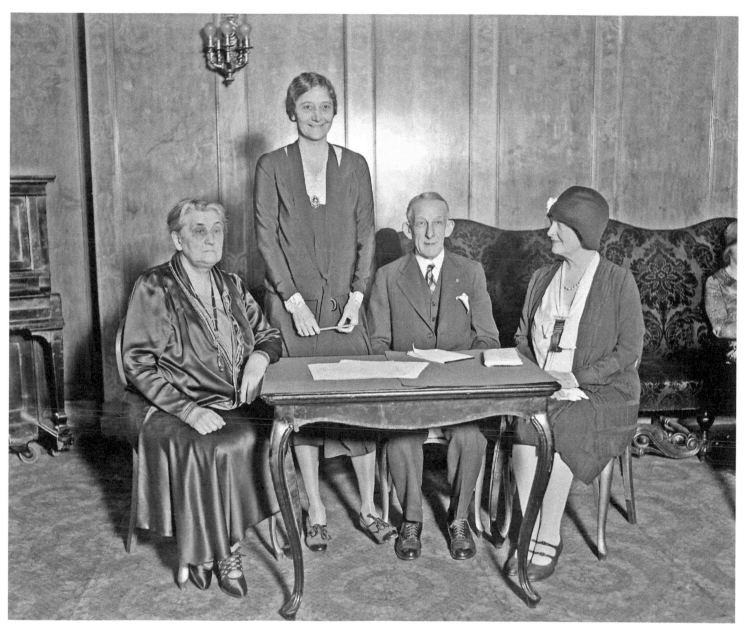

Jane Addams, President of Hull House, Ruth H. McCormick, U.S. Representative-at-large, Governor Louis L. Emmerson, and Mrs. Bertha Baur met in Chicago in 1929.

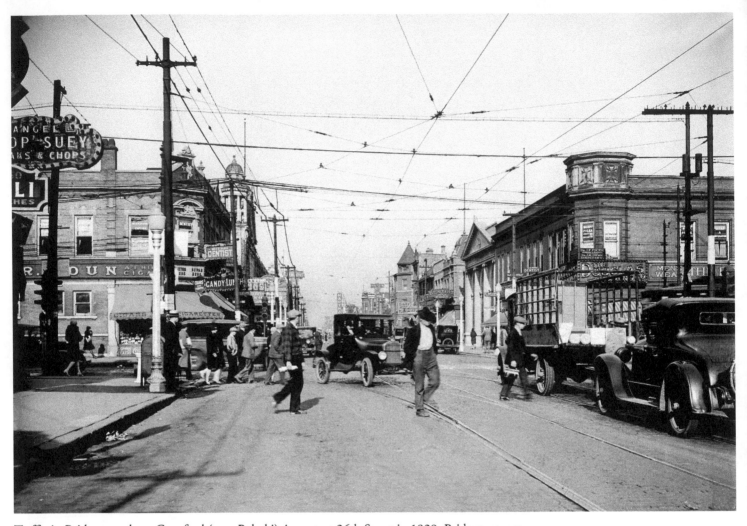

Traffic in Bridgeport along Crawford (now Pulaski) Avenue at 26th Street in 1929. Bridgeport was settled in the mid-1800s, primarily by Irish immigrants who worked on the Illinois and Michigan Canal. Bridgeport has been the home of five Chicago mayors: Edward Kelly, Martin Kennelly, Richard J. Daley, Michael Bilandic, and Richard M. Daley.

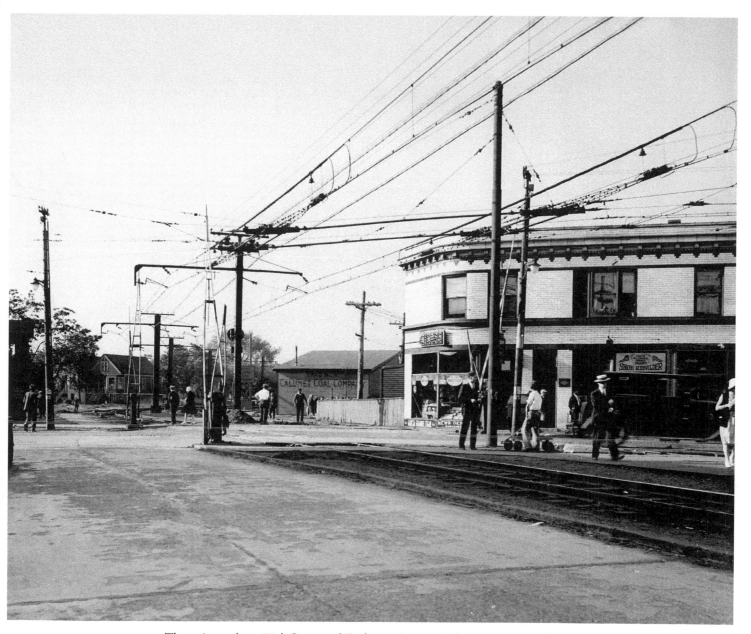

The train tracks at 79th Street and Exchange Avenue in the community of South Chicago in 1929. Following the Chicago Fire, much industry migrated south to this area. South Chicago was annexed to Chicago in 1889. The steel industry attracted many workers, who settled in ethnic pockets in the community.

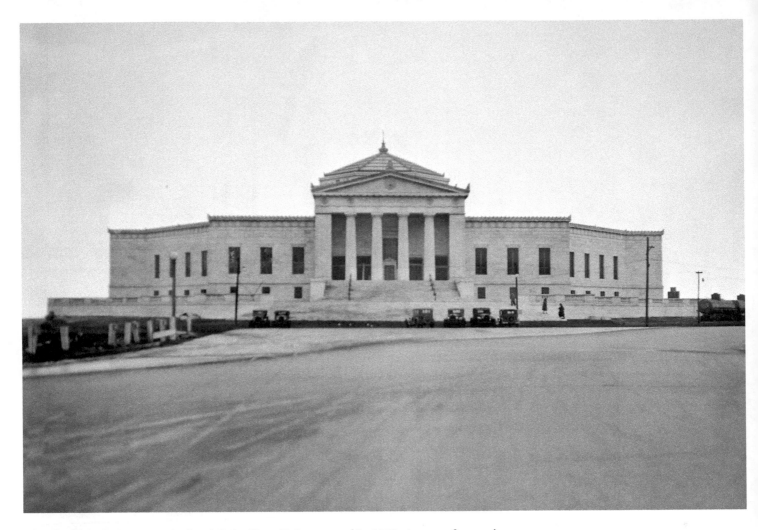

The Shedd Aquarium, at 1200 South Lake Shore Drive, opened in 1929. A team of researchers traveled the world for ten months investigating the design and operations used in other aquariums before finalizing plans for the Shedd.

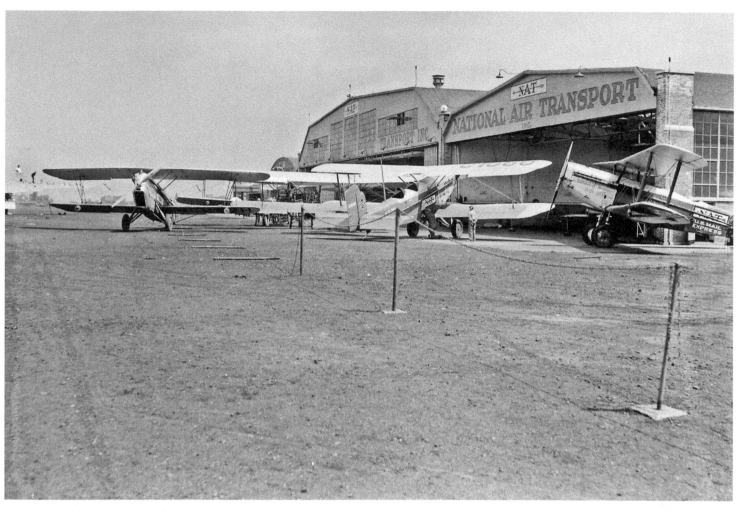

Airplanes sit on an airfield at the Chicago Municipal (later Midway) Airport in 1929. Originally built in 1922 as the Chicago Air Park, primarily for airmail contractors, it was dedicated in 1927. It was the "World's Busiest Airport" from 1932 until 1962 when O'Hare Airport captured that title.

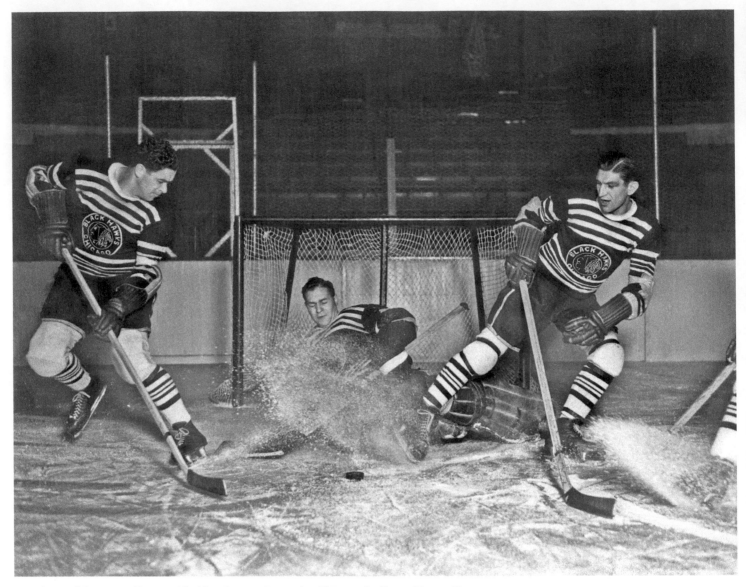

Members of the 1933 Chicago Blackhawks practice at the Chicago Stadium. Pictured here (from left to right) are: Paul Thompson, Chuck Gardiner, and Johnny Gottselig. In the 1933-34 season, the Blackhawks captured the Stanley Cup, winning the final game against Detroit in overtime, with all-star goal tender Gardiner earning a shutout. Two months after the victory, Gardiner died of a brain hemorrhage.

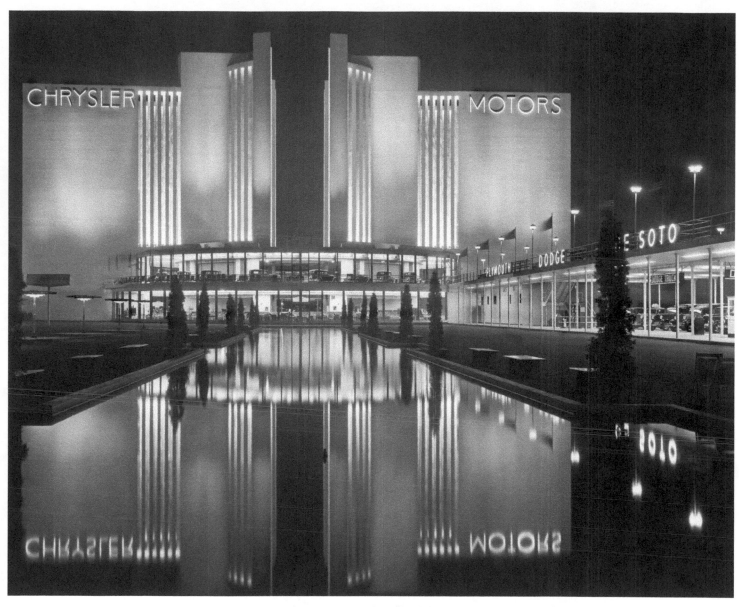

Linear Art Deco design was a trademark of the Century of Progress held in Chicago in the summers of 1933 and 1934. Here, the Chrysler Pavilion is mirrored in the water of the pool at its entrance.

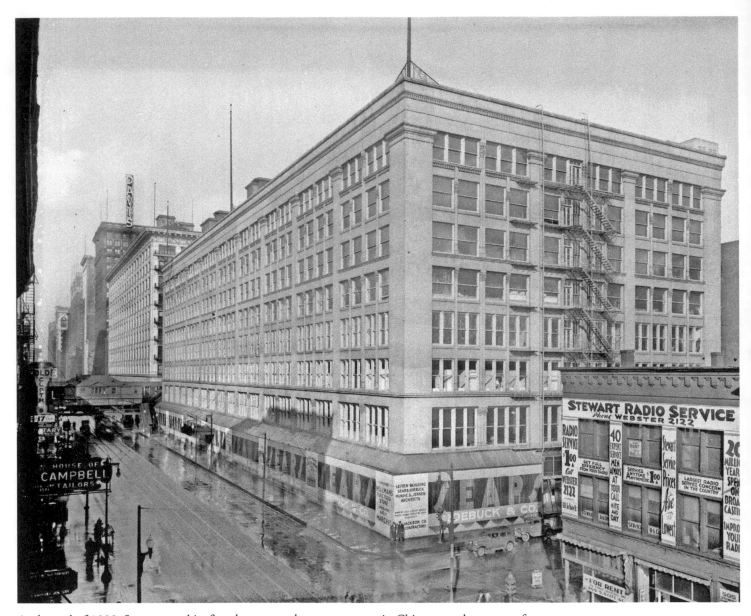

At the end of 1932, Sears opened its first downtown department store in Chicago on the corner of
Van Buren, State, and Congress streets, spending over a million dollars to remodel the former Siegel,
Cooper & Co. department store. On opening day, more than 150,000 shoppers visited the store. The
new store brought 1,000 much-needed jobs to the city in the midst of the Great Depression.

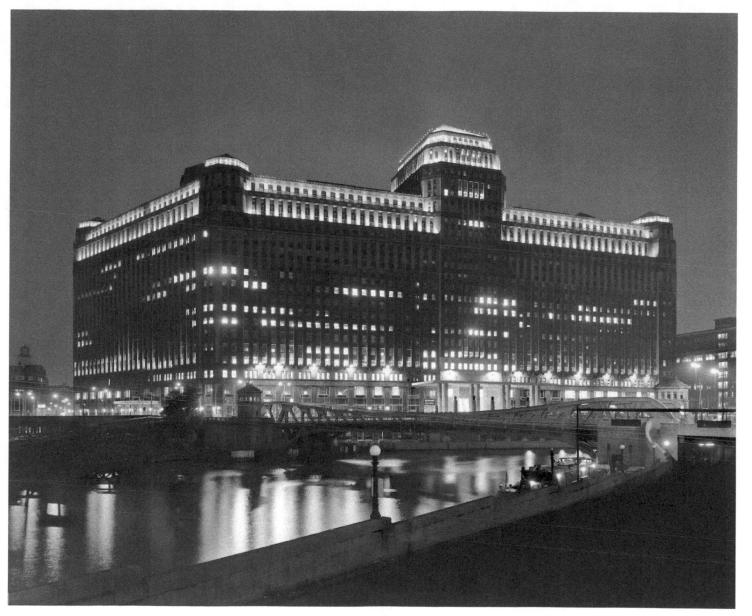

When the Merchandise Mart opened in 1930, its floor space made it the world's largest building. It held that title until 1943, when it was overtaken in size by the newly opened Pentagon. It was built by Marshall Field and Company to consolidate Field's wholesale activities. Joseph P. Kennedy would purchase the building in the 1940s.

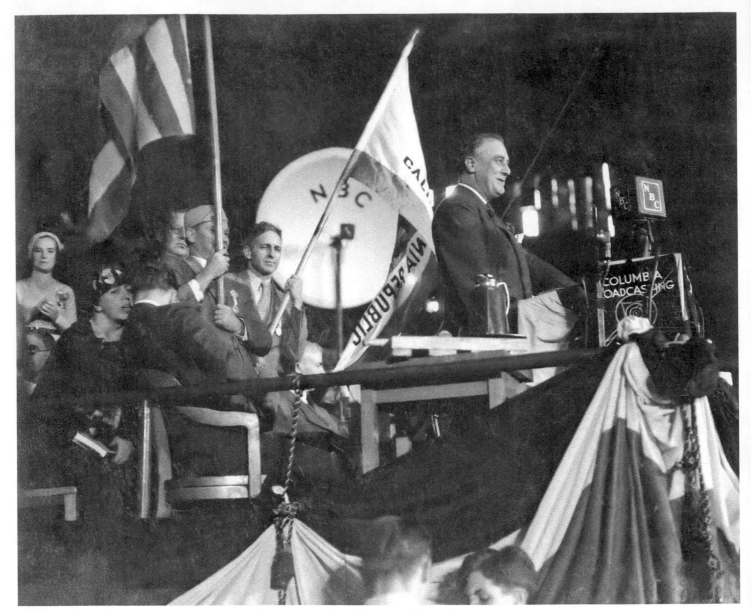

In 1932, Franklin Delano Roosevelt accepted the presidential nomination of the Democratic Party at the Chicago Stadium. President Roosevelt would return to Chicago in 1940 and 1944 to accept his party's nomination for his third and fourth terms.

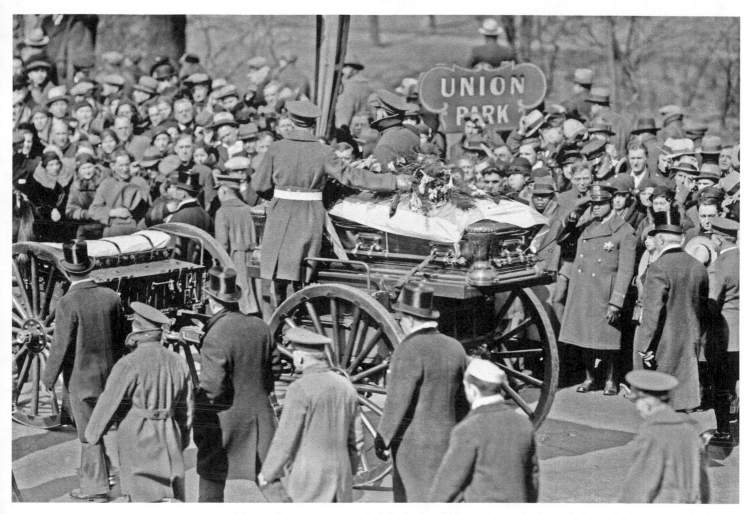

A horse-drawn wagon carried the body of Mayor Anton J. Cermak through the streets of Chicago on March 10, 1933. Mayor Cermak, known as the father of Chicago's Democratic machine, beat incumbent William Hale Thompson in 1931. Mayor Cermak was shot in Miami Beach, Florida, on February 15, 1933, in an assassination attempt on President-elect Franklin Delano Roosevelt.

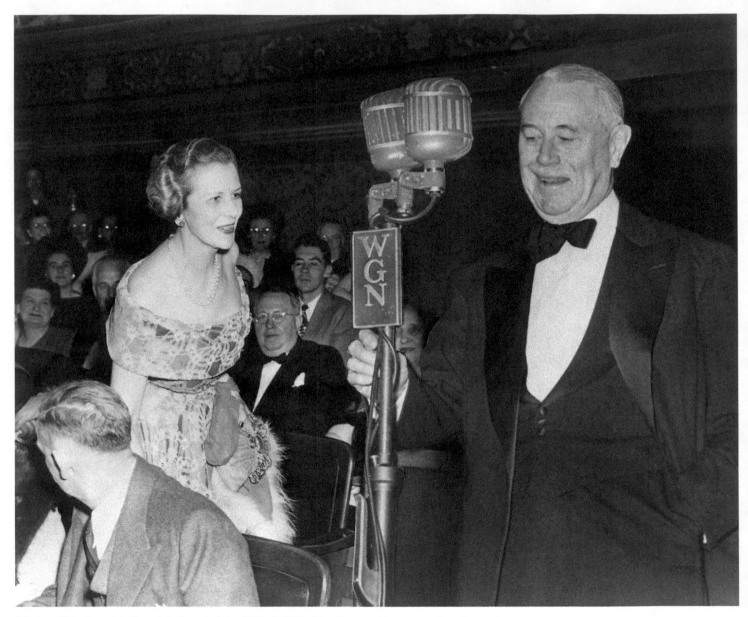

"Colonel" Robert McCormick founded the WGN ("World's Greatest Newspaper") radio station.

The City in the Postwar Era

(1940s–1960s)

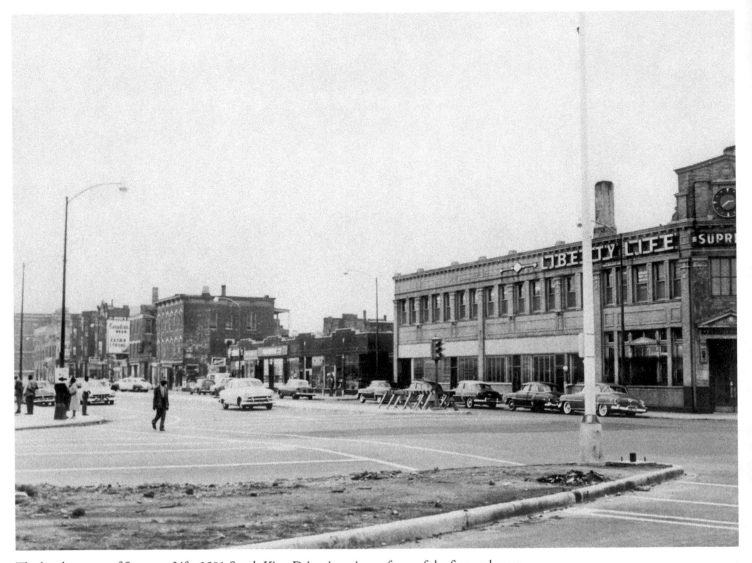

The headquarters of Supreme Life, 3501 South King Drive, is an icon of one of the first and most successful insurance businesses owned by an African-American. Businessman Frank L. Gillespie founded the company in 1919 as the Liberty Life Insurance Company. Supreme Life, formed from the merger of Liberty and two out-of-state firms, was one of the few businesses of the "Black Metropolis" to survive the Great Depression.

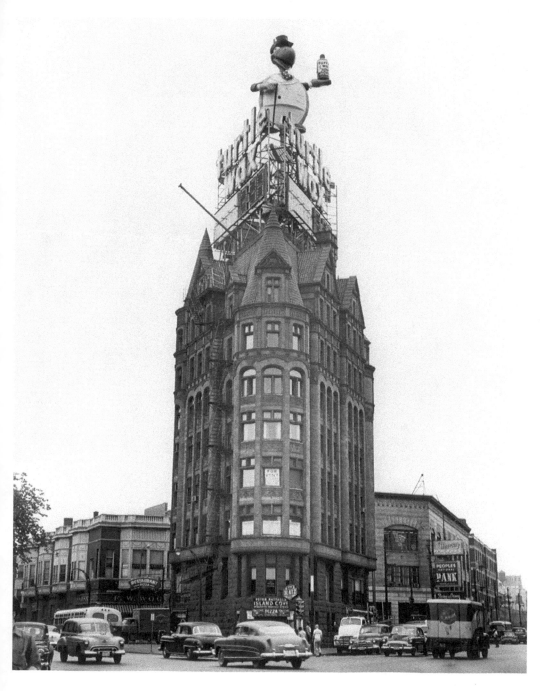

The Turtle Wax storefront on Madison, Ashland, and Ogden. Ben Hirsch started the company with his wife, Marie, initially mixing the car polish in a bathtub. One of his methods was to polish the bumper of a parked car, wait for the owner to come, and sell him a bottle of the polish. The company still has its headquarters in Chicago.

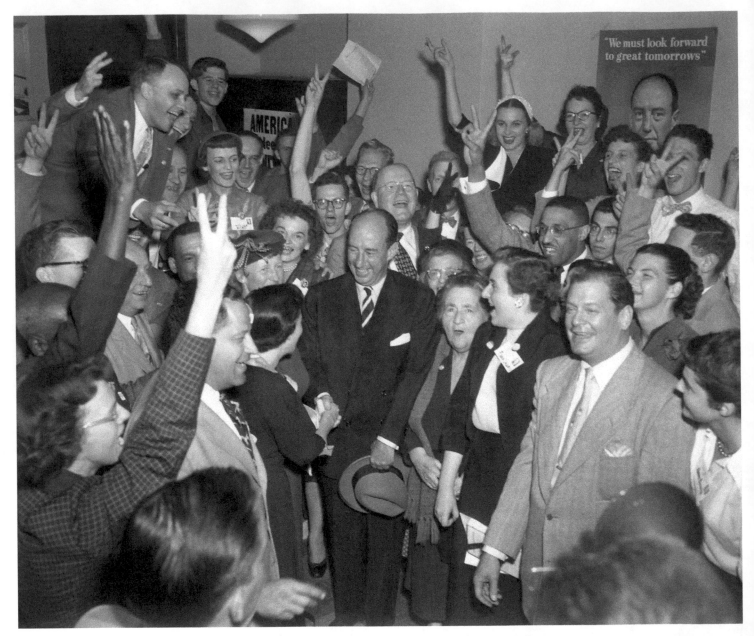

In 1952, Democrats gathered in Chicago for the national convention and nominated Illinoisan Adlai Stevenson II. A few weeks earlier, Republicans had nominated Dwight Eisenhower in the same venue. These were the first conventions nationally broadcast on television.

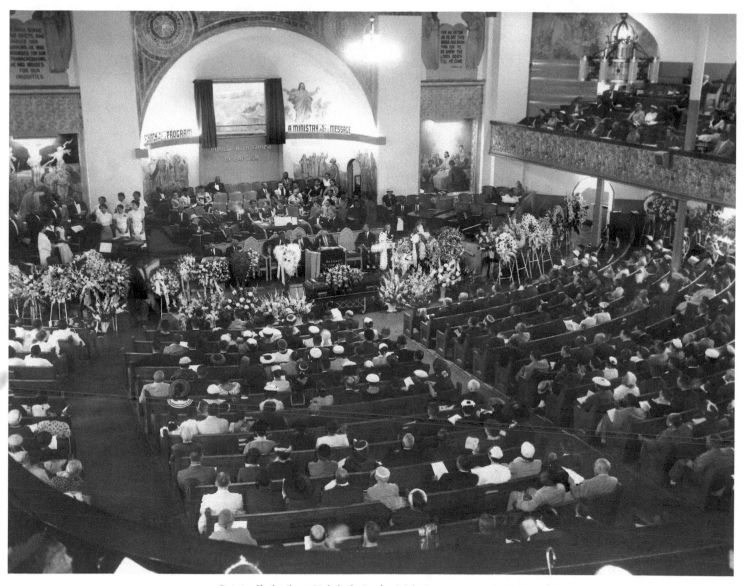

Originally built as Kehilath Anshe Ma'ariv synagogue in 1890, this structure at 3301 South Indiana Avenue was designed by Adler & Sullivan. It has housed Pilgrim Baptist Church since 1922. One of the church's first music directors, Thomas A. Dorsey, became known as the "Father of Gospel." It is shown here during the 1956 funeral of Robert Alexander Cole, one of the city's wealthiest African-Americans of that era. In January 2006, a fire sparked by roofing work gutted the building.

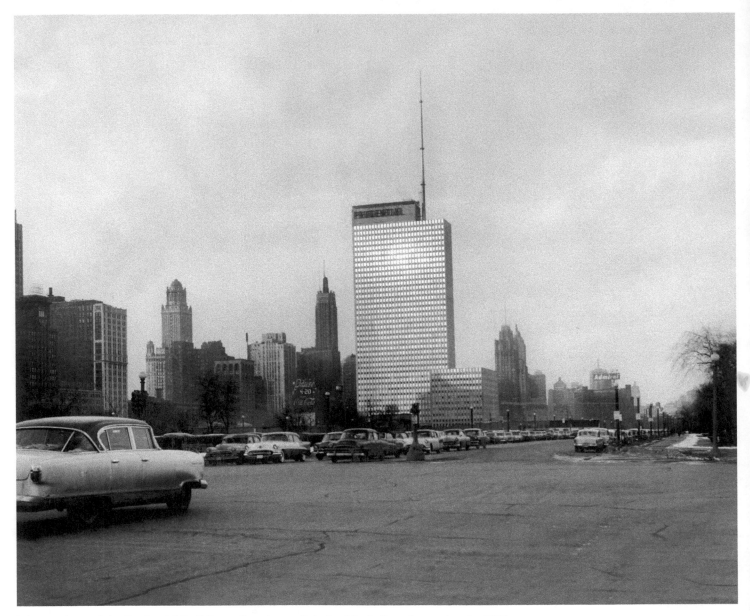

The windows of the Prudential Building reflect the sunlight in this skyline photo taken in 1956.

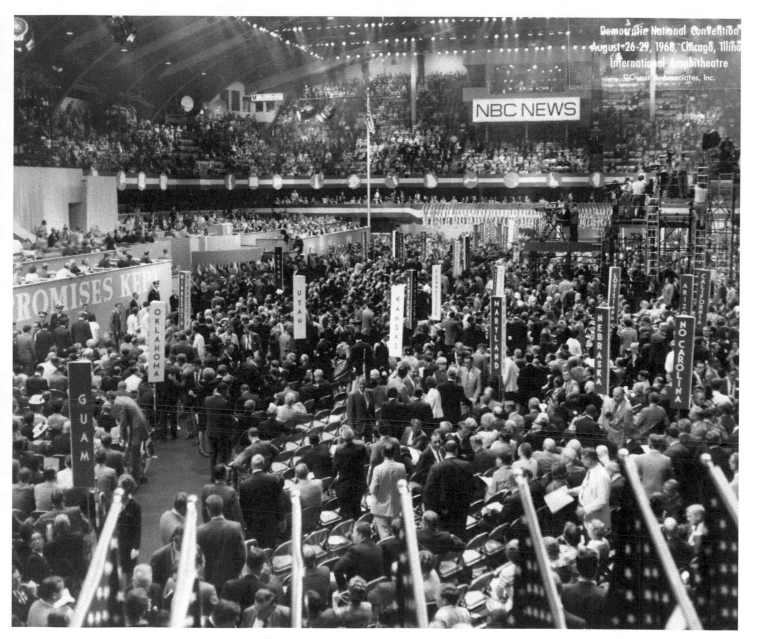

Support of antiwar candidates Eugene McCarthy and George McGovern created tension at the 1968 Democratic Convention. In the end, delegates inside the International Amphitheater nominated Hubert Humphrey and, for vice-president, Edmund Muskie.

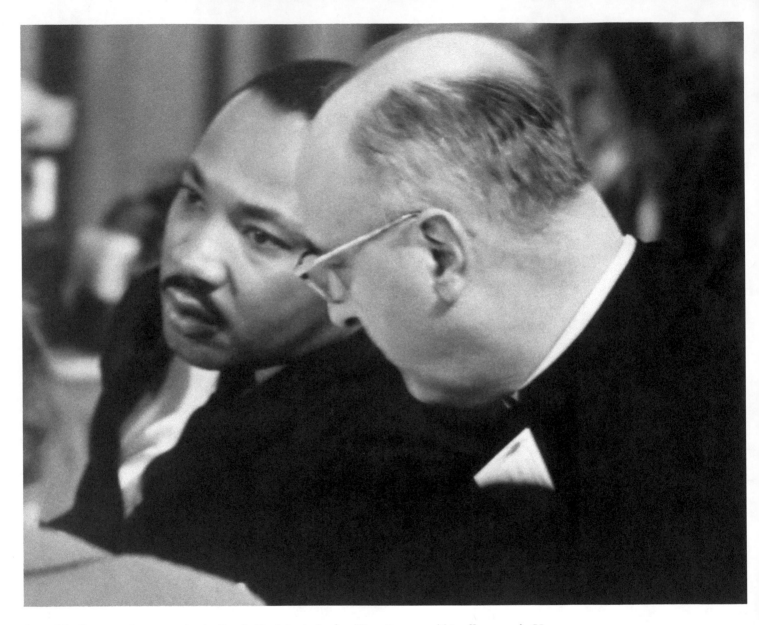

In 1966, after several successes in the South, Dr. Martin Luther King, Jr., moved his efforts north. He is shown here at an Illinois Rally for Rights. In an effort to bring attention to the living conditions of Chicago's poor African-Americans, Dr. King and his family moved into the city's slums while working in Chicago.

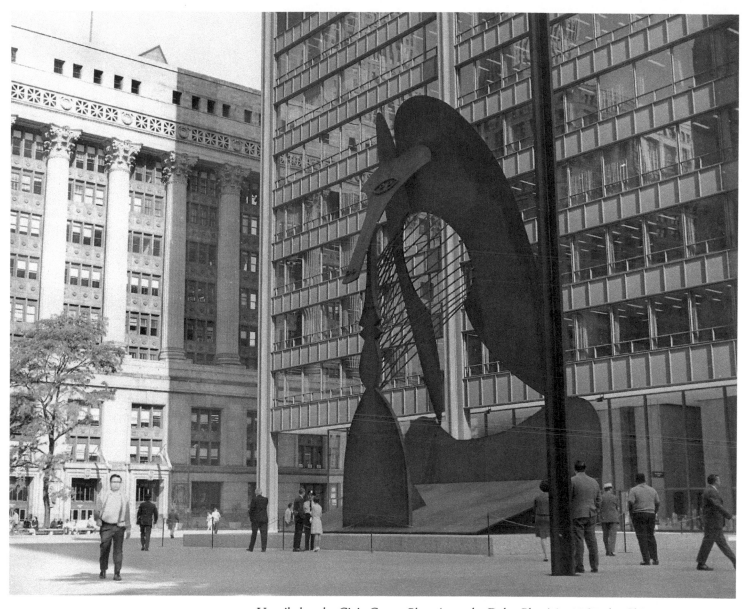

Unveiled at the Civic Center Plaza (now the Daley Plaza) in 1967, the Chicago Picasso is an unpainted, three-dimensional, cubist sculpture standing 50 feet tall and weighing 162 tons. U.S. Steel's nearby Gary Works fabricated the sculpture from the same Cor-Ten steel used to build the Daley Center building.

Notes on the Photographs

These notes, listed by page number, attempt to include all aspects known of the photographs. Each of the photographs is identified by the page number, a title or description, photographer and collection, archive, and call or box number when applicable. Although every attempt was made to collect all data, in some cases complete data may have been unavailable due to the age and condition of some of the photographs and records.

Printed in the USA
CPSIA information can be obtained
at www.ICGtesting.com
JSHW072023140824
68134JS00042B/3762